Capturing Love

THE ART OF
Lesbian & Gay Wedding Photography

Thea Dodds & Kathryn Hamm

authentic WEDDINGS

Dedications

Thea: *For Bryan, and our daughters, Kyra and Aubrie*

Kathryn: *For my beloved, Amy, and my mother, Gretchen. Without whom...*

Contents

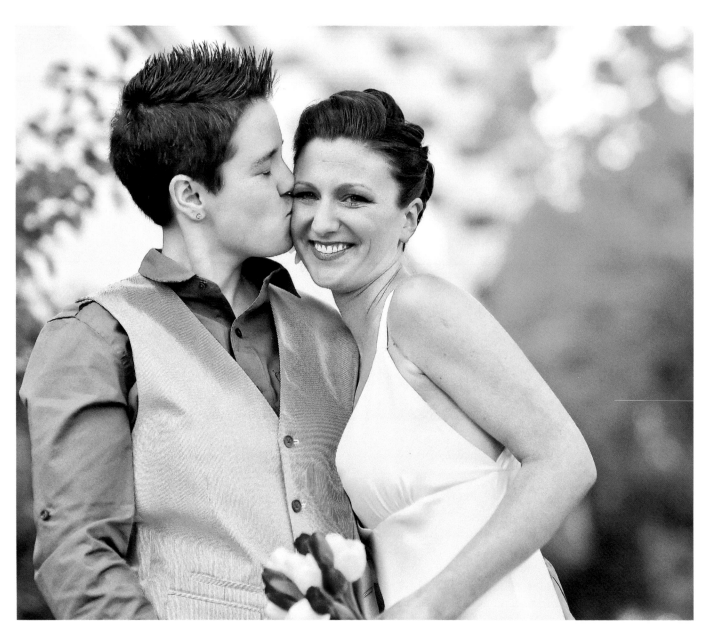

Foreword

As recently as a few short years ago, a book like *Capturing Love: The Art of Lesbian & Gay Wedding Photography* would not have been possible or as fully appreciated as the essential tool that it is. But, thankfully, times have changed.

Just as the digital camera has impacted the course of professional photography, and just as the Internet revolution has redefined the rules of the wedding industry, same-sex weddings have fundamentally altered how wedding pros think about their businesses and how engaged couples think about their planning. And the intersection of all three has undoubtedly played a significant role in the creation of this book, which, informed by the authors' seasoned perspectives, expert narration and the lenses of thirty-eight photographers, transforms our understanding of engagement and wedding photography.

Promising to provide professional photographers with an effective resource to better serve same-sex couples, this collection of inspiring images delivers something for everyone. The loving couples celebrated here reveal tradition and purpose, shared intimacy and meaningful moments. It is a portfolio that is powerful, beautiful and extraordinarily important for our society. I deeply appreciate and respect the work Kathryn and Thea have curated. I know that you will, too.

TIMOTHY CHI
Chief Executive Officer, WeddingWire

Preface

THE MOMENTS THAT MATTER MOST can come quite unexpectedly. And often, time slows down just enough to help you record more deeply the moment as it is unfolding. It's as if a bright spotlight appears on something you may not have recognized, or perhaps you had seen, but could not yet articulate. But there it is: right in front of you, asking for your attention and care.

These are moments of significance. Because once seen, the moment moves from passing to indelible.

I've had a number of those moments in my life; notably and topically, the moment of my coming out to myself, realizing that, "Oh wow, I like women. I mean, *really like* women." I also count the moment that something crystallized for my straight mom, who founded our groundbreaking business back in 1999. Defying the odds and opinions, she built the first online wedding boutique dedicated to serving same-sex couples after realizing that there were many couples in need of specialty products and services but unable to find them.

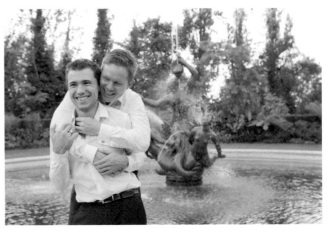

PURPLE APPLE STUDIOS

And newest to my count: receiving a call from photographer Thea Dodds, to whom I now proudly refer as my business partner, co-author, and friend. She had called me with an idea she wanted to share. "Weddings are changing," she said, "and photography education needs to change, too."

She revealed her thoughts on wedding photography in general and how same-sex couples are underserved by the accepted (predominantly heterosexual) industry standards for engagement and wedding portraiture. In turn, this led me to reflect on

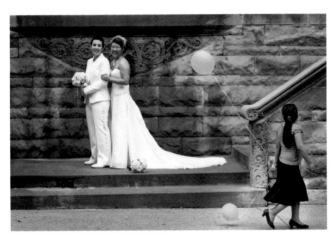

In that moment, time slowed, that bright spotlight appeared, and an indelible moment became a new mission.

• • •

Before we dig into the background of basic portraiture techniques, the backstory on same-sex couples, and the significance of their wedding and commitment rituals, let me take a quick moment to say a little something about the beautiful collection of photographs included in this book.

Thea and I are indebted to the many talented photographers who enthusiastically shared their work with us. We hope you'll take a moment to learn more about them in the Contributors section (p. 79). And, of course, this book would not be what it is without the many vibrant and loving couples who hired these photographers to document their engagements and unions. But, more importantly, these couples had the courage to let the light of their love shine brightly and beyond the boundaries of the personal moments you see captured here.

many of the photography submissions I've received for GayWeddings.com: plenty of couples in love, and plenty of good shots, but not as many *great* shots. Many of the submissions were missing something. A subtle, but essential, something.

In the course of our conversation, thanks to Thea's expertise, I understood more fully what it was that I couldn't quite put my finger on. It was this: what works in wedding photography for John and Barbara, won't necessarily work for Matthew and Rick, let alone Jill and Louise.

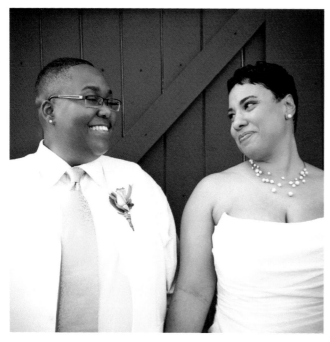

In choosing these photographs, we sifted through thousands of engagement and wedding images before selecting those that illustrate key points about the art of photographing same-sex couples, while also answering affirmatively three critical questions: Are these images authentic? Do these images reflect intimacy? Are these images believable?

Yes, these are real couples and real moments and these are couples with as diverse a range of expression as range of physical characteristics. This representation is so important because the LGBT (lesbian, gay, bisexual, transgender) community is incredibly diverse in so many ways. As we begin, square one is understanding that a one-size-fits-all approach to working with same-sex couples will not be effective.

It is true that, in any photograph, if an authentic moment can be captured, the photograph will have an impact that can be transcendent. These are the images photographers want to include in a client's album and these are the images a couple wants to display proudly at home, in the office, or on a holiday card.

There is an art to creating, inspiring, and capturing these moments and this is the vital work and responsibility of the photographer. You

know this and that's why you have opened the pages of this book.

We are grateful to have this opportunity to bask with you in the love of couples who are excited to embrace the privilege and responsibility of marriage, and who are blazing a path right along with us. To the extent that, with this book, we can help to inspire and expand the market's readiness to better accept and serve same-sex couples, we will have achieved our purpose.

Kathryn Hamm
November 2012

Background

EVERY WEDDING IS STEEPED in tradition. No matter how unique, religious, or traditional the wedding, there is a fundamental structure—a purpose—guiding each exchange of vows. That is: a couple stands before its witnesses to exchange a promise of commitment, resulting (for most couples) in a civil marriage license recognizing the partnership in legal terms.

In engagement and wedding photography, the same dynamic holds true. No matter the job at hand, there is a structure—a purpose—guiding each session. A photographer is hired to be on hand to document a relationship or a moment of celebration or love, and, to do so, follows a given set of "rules" or best practices for the session. If all goes well, the result is a stunning image, a valuable keepsake for the couple, a feeling of pride for the photographer, and perhaps even a chance to be published in a magazine or popular blog.

But, when it comes to "capturing love," especially when a modern couple is the subject, rules were made to be broken. Reassembled. Reinterpreted. Revised. Repurposed. And that is the gift that same-sex couples have introduced into the wedding trends of today. Same-sex couples adhere to many wedding traditions in their ceremonies, but they also discard the rituals that do not pertain to them and repurpose the ones that need adjustment to become more relevant.

Because more couples than ever are creating personally meaningful ceremonies and receptions, photographers must be vigilant in their efforts to understand how a couple—straight or gay—wishes to present itself and be understood. Applying an ill-fitting frame of reference to what should be a moment of authenticity of expression can have awkward results.

A successful photographer must understand and anticipate this and have the professional wisdom to nudge the authentic and intimate moments into being, translating them artistically with a well-framed and purposeful click of the shutter.

Take, for example, the canon of pose books for photographing couples; one can find, almost without exception, heterosexual couples and traditional wedding moments (e.g. a man and a woman, a tux and a wedding gown, wedding parties divided by gender, a bouquet toss,

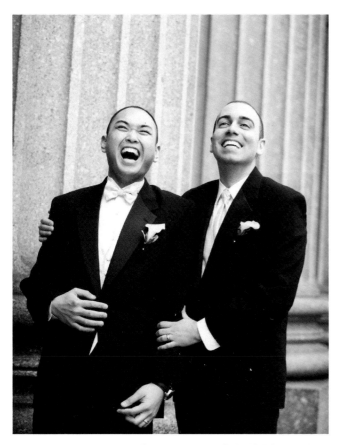

LESLIE BARBARO PHOTOGRAPHY

and his father, or a reception without staged wedding moments like the cutting of the cake.

WHAT'S A PHOTOGRAPHER TO DO?

Start by revisiting the rules of traditional wedding and engagement portrait techniques and then develop an expanded skill set to better serve *all* couples in today's dynamic wedding market. And that's what you'll find here: a groundbreaking guide that not only highlights some of the best same-sex engagement and wedding photography from the past few years but also offers some valuable and practical solutions to incorporate into your next engagement session or wedding.

Though this guide won't dwell on the current "best practices" in engagement and wedding photography, it will lean on them. And though it won't propose one definitive answer for every single situation, it will offer a path toward a deeper understanding of working with same-sex couples in order to unlock the potential of the moment and produce the best result.

Just remember: it's okay to be a beginner. Regardless of your level of comfort in this subject area, an openness to learning more, making mistakes, proposing solutions, and asking

the first dance). These suggestions can be a helpful starting place when thinking about how to pose a couple or photograph a wedding, but an over-reliance on an outdated standard can be problematic if a photographer shows up unprepared for two brides in pants, a mixed gender wedding party, a dance between a groom

respectful and thoughtful questions will bring improved results to your work.

SQUARE ONE: THE OLD STANDARD

Traditional standards have held up over time because of habit and effectiveness. The pose books that are currently available for reference can be helpful because many of the suggestions *do* work and the techniques *are* effective. This same selection of pose books, however, can also be limiting, largely as a result of reinforcing old habits without deeper reflection and adaptation.

Though newer wedding and engagement sourcebooks show an increasing amount of diversity (more interracial couples, more mature couples, more ethnic representation), they largely represent Caucasian brides and grooms who express themselves in traditionally gender-normative ways.

Today, couples can be parents, can have divorced parents, can have six grandparents, can have blended ethnic or religious backgrounds—and they can be same-sex couples. Even so, these couples are much harder to find in the canon of photography reference books. Thus, photographers must be mindful of the proven techniques for photographing

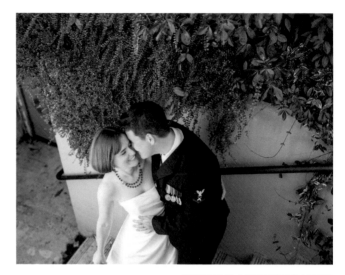

EMILY G PHOTOGRAPHY

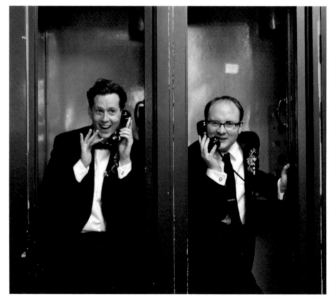

ARIELLE DONESON PHOTOGRAPHY

couples, but also be prepared to reject the rules that don't apply and adapt to the changing needs of their clients.

But before breaking any rules, make sure you first know what they are! Many of the general concepts from what we refer to as the Old Standard are woven through this guide and will be important to recognize when you see examples of these rules working—or being insufficient—for some couples.

Our short list of Old Standard keepers includes:

The rules of composition never get old. The rule of thirds can be used both horizontally and vertically for maximum impact.

Where you crop matters. The three traditional crops are: 1) full body; 2) at the knees; and 3) at the elbows. Avoid crop lines at the top of heads, the hands or the feet.

Work it, girl! With a three-quarter turn. It's more visually dynamic for a person to turn his or her body slightly away from the camera and then look back toward the camera to create depth and dimension in the face.

A unique perspective adds to the story. In framing a shot, consider an ant's eye view or a bird's eye view; a wide shot or a tight shot; or create an additional frame by looking through something.

A little tilt goes a long way. Playing with angles adds visual tension.

Lead the viewer's eye. Use lines and natural angles to draw the viewer's eye through the frame toward the subject(s) featured.

Finish strong! Always finish an image with a thoughtful and visible placement of the hands and feet. Give the hands something to do or help them find a place to rest, and avoid a mess of arms and hands.

MAKING THE LEAP

Though the foundations of posing couples found in the Old Standard can be helpful in guiding a session with a same-sex couple, a photographer must be prepared to pivot and meet the couple where they are. This includes the obvious physical details of the relative body size and shape of the couple and the attire they have selected, but it also includes a more subtle understanding of how the couple relates to one another and their comfort in showing their authentic selves during an engagement session or at their wedding.

Experienced photographers know that it takes some time to get the average couple to relax, feel less self-conscious and "be themselves" when the lens is trained on them. In working with same-sex couples, this dynamic can be complicated further. Is the couple comfortable showing physical affection in a public setting? If so, to what extent? Is the photographer comfortable and familiar with a same-sex couple in a loving embrace? Thankfully, more gays and lesbians than ever are "out and proud" and, as such, feel more comfortable being themselves in public setting and, conversely, more members of the general public are accustomed to seeing same-sex couples hold hands or embrace.

As far as our society may have come, do not underestimate the reality of a habit of caution for some same-sex couples—especially those who do not live in large cities or areas where their marriages are legally recognized. One does not have to look far to find examples of lesbian, gay, bisexual, and transgender (LGBT) individuals who have been bullied or worse, and as a result, may be less comfortable showing public affection with a partner than less marginalized couples.

As photographers make the leap to new ways of thinking about engagement and wedding photography, it's also important to understand what the LGBT community is and what it isn't.

The community is as broad and diverse as one might imagine, and while the community has many shared objectives geared toward seeking partnership recognition and equality, it's important to know that being an "L" isn't the same as being a "G" and neither of those are the same as being a "T."

That's why, for the purposes of this book, we refer to "same-sex couples," meaning those couples who identify as being in a relationship with someone of the same sex. In other words, the individuals in these couples could identify as lesbian, gay, bisexual, or transgender, but we're referring to the ones whose cake toppers will depict two women or two men—albeit with some variation in gender presentation possible.

So, while we talk about being LGBT inclusive, which is becoming an increasingly common practice in the wedding industry, it is important to keep in mind that many transgender individuals are in a heterosexual relationship for which many of the traditional rules of wedding photography for opposite-sex couples might apply just fine!

Regardless of how any couple identifies, the most important thing that a photographer can do for a couple—straight or gay—is not to presume anything about how the lovebirds relate to each other or wish to express themselves. If a

photographer can meet the couple where they are, welcome an authentic expression of their love, and inspire them to let it shine, the job at hand can be as simple as making sure that the lighting is favorable and the lens is in focus.

A NEW, AUTHENTIC STANDARD

Photographing couples of the same body type, weight, and height can be hard at times. It's hard because wedding and portrait photographers are largely taught guiding principles that work for the "average" couple, which has traditionally been defined as a fit, Caucasian, heterosexual couple, dressed in opposing colors, with the man standing approximately four inches taller than the woman.

To address a new Authentic Standard in which one size does not fit all, engagement and wedding photography requires a seasoned approach, hewn from the best parts of the Old Standard, that also allows a twist here and a tweak there to make the frame relevant to the couple at hand.

When a photographer has mastered the basics of the Old Standard and is ready to break the rules for a better result with same-sex couples (or any

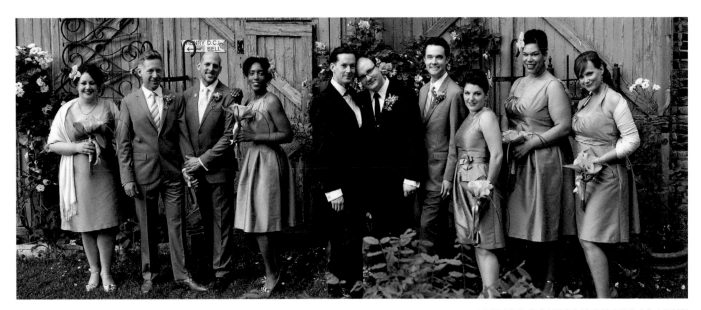

ARIELLE DONESON PHOTOGRAPHY

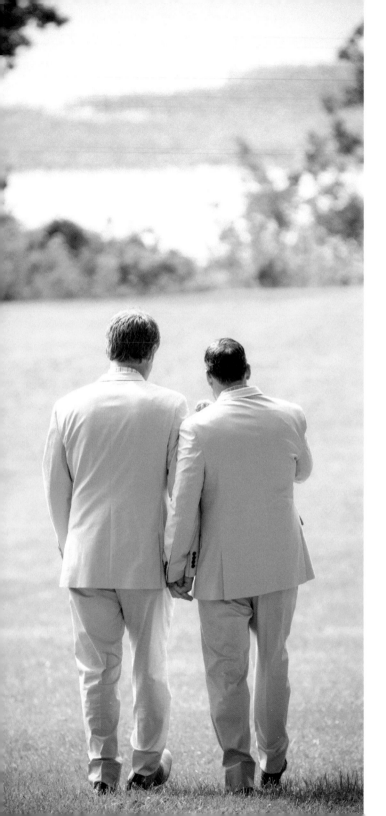

other couple who doesn't fit the average mold), we advise following:

Understand gender expression. Look beyond the attire selection, but be prepared to embrace it. Photographers must visually respect gender expression by embracing how the individuals (as individuals and as a couple) self-identify. Do not presume that in every same-sex couple one partner is the "masculine one" and one is the "feminine one" and that, as such, they should be assigned to the standard male-female poses. Take the time to get to know the couple and their relationship and how they are comfortable expressing themselves to better understand how to pose them organically.

A little playfulness goes a long way. To get a couple to behave "naturally" in front of the camera, have fun with them. The resulting images often aren't polished or perfect, but the natural moment can overpower any conceptual imperfections. It's also important to recognize that many same-sex couples appreciate the irony of their two bride or two groom take on wedding tradition. If it feels right, play it up!

CHRIS LEARY PHOTOGRAPHY

Use symmetry to your advantage, but not as a crutch. When you are working with two persons of the same gender who might have similar features and be dressed in the same style and/or color, it's easy to fall back on the age-old standby of symmetry as an overriding concept. Don't be tempted to take the symmetry shortcut in every shot. Instead, we challenge you to do more than rely purely on the obvious symmetry of two brides or two grooms. When working with a same-sex couple, feel free to play with the symmetry, but push yourself to create an authentic and visceral message about the couple's relationship and its place in the world.

Turn a challenge into an asset. Don't get stuck trying to fit a square peg into a round hole; look for the square hole or the round peg and innovate. This is something that, with proper preparation and quick thinking, creative professionals do well. For example, the next time you have a couple who can't physically dip or lift one another to replicate one of your favorite poses, work a way around it seamlessly because you are prepared for it.

Be mindful of body basics when directing hand placement. A photograph between a man and a woman, with a hand resting lightly on the chest, is a tempting pose to employ on a same-sex couple. But tread with care. Do the masculine and feminine roles implied in this pose apply to this couple? Or, does this pose used on two women border on groping? Hands can be placed on the cheek, chin, forearm, or hip, but be mindful of arm-length and extension. A slight bend is best and one should never force a wrapping hug if the wrapper's arms fit awkwardly around the wrapee.

Share advice...before the session. Photographers often have more experience about how location or attire, from textures to colors, can impact a shot. Don't assume that the couple is thinking about the difference a color scheme makes from a photographic standpoint or how attire and location choices will impact the session. Have these conversations in advance to be prepared for variables dependent on the couple and the day of the session.

Be creative with group shots. Same-sex couples typically have some sort of a wedding party but the attendants assembled can vary widely from tradition. There are mixed-gender wedding parties; no wedding parties; imbalanced wedding parties; costumed wedding parties; family as wedding party. You name it, same-sex couples have done it. Learn more about who your clients want to feature and how they want to feature them before the event and use that understanding to create meaningful and authentic group shots.

Be mindful of the role of family. Though more parents than ever are excited about their gay son or lesbian daughter's wedding, there are still many examples of parents who aren't supportive and either aren't invited to the wedding or have declined the invitation. Be sensitive about this reality, asking open-ended and respectful questions about what a couple envisions for the inclusion of family members, while also remembering that the family members—sisters, brothers, parents, grandparents, aunts, uncles, children—who do attend may very well provide some of the most moving and authentic moments of love to be captured.

CAPTURING LOVE

This book is organized around the engagement sessions and weddings of real same-sex couples, and each scenario includes brief examples of techniques that work, followed by visually-inspiring featured images and illustrated analysis.

Same-Sex Engagements. This section includes a combination of same-sex couples, recommended techniques, and the essentials for making the most of an engagement session.

Same-Sex Weddings. This section is divided into two parts—Two Grooms and Two Brides—highlighting essentials techniques and tips, and declassifies the unique aspects of working with two men or two women.

Conclusion. This section offers our take on this constantly shifting landscape. Though there are plenty of examples to build a modern foundation for new directions in engagement and wedding photography, new trends are emerging quickly as the legal landscape shifts toward marriage equality.

Glossary. Stuck on a technical term or new concept? This section offers simple definitions for some of the most important terms referenced in the book.

Contributors. This book would not be possible without the generous contributions of the many photographers (and couples) who know a lot about "capturing love" and were willing to share their work with us. Get to know them.

We hope that this guide will inspire new insights, deeper questions, and new solutions for photographing same-sex couples. And for those of you looking to share your inspiring photographs or see more examples of outstanding same-sex engagement and wedding photography, please visit our website: www.capturingloveguide.com.

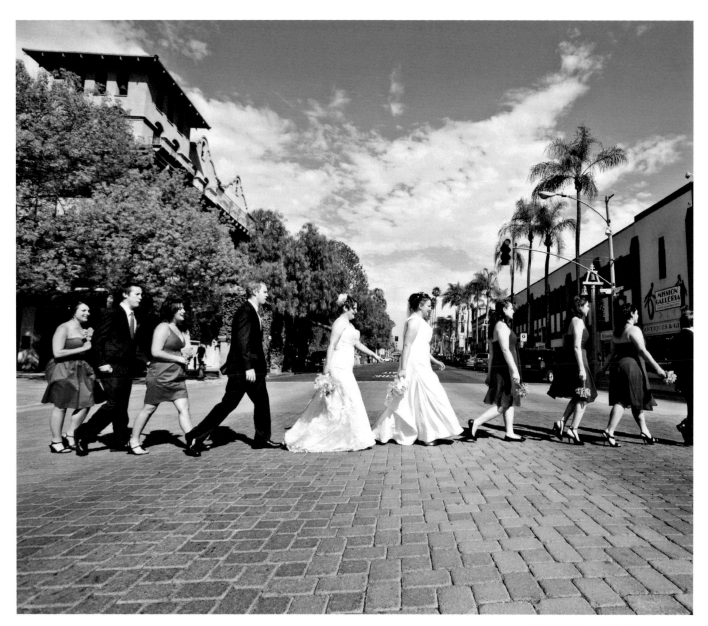

Same-Sex Engagements

TEN YEARS AGO, fewer same-sex couples were considering a public ceremony, and even fewer had access to legal partnership recognition. When couples did forge ahead into uncharted territory, most of their energy was invested in finding gay-friendly vendors, making sure that the wedding basics got covered, and worrying about whether or not family would show up. Engagement sessions were not yet a gleam in the collective LGBT eye, let alone the reality that they now are in the blogosphere.

As same-sex weddings have become more widely accepted and embraced, more couples have begun to follow the traditional marriage prescriptions: engagement on bended knee (or Jumbotron), engagement parties, bachelor/bachelorette parties, wedding showers, weddings, and big receptions. You know, The Works.

These changes require that photographers take a deeper look at the kind of services they are offering same-sex couples and more critically examine their portraiture skill set. Couples, too, will be well served to become more knowledgeable about the kinds of skills, style sense, and creative talents available to them when hiring an engagement and wedding photographer.

If used well, the engagement session can provide fruitful inspiration for wedding day planning.

Tip: *The clients and photographer need to be a team with a shared set of goals. This is a key time to establish connection and build rapport.*

Tip: *Observe your clients and consider: How does each individual express him/herself most comfortably, especially with regard to gender expression? How does each partner relate to his or her beloved? In what ways have their "coming out" experiences impacted them and their family relationships?*

Tip: *Engagement sessions are a low-risk time to take chances. Try out a new shot, a new pose, new lighting. Figure out what works with this couple and what doesn't.*

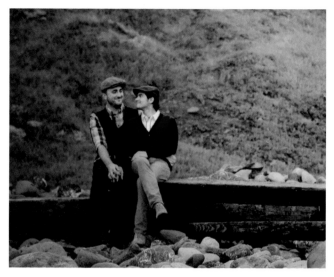

RETROSPECT IMAGES

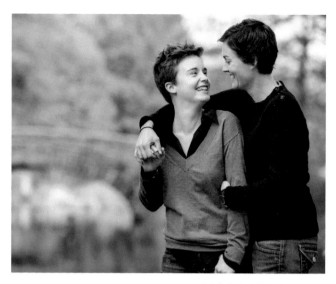

ARS MAGNA STUDIO

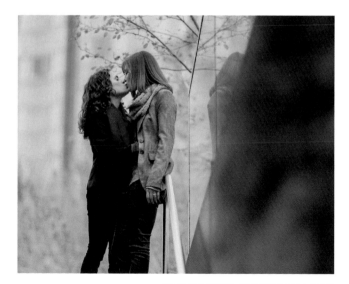

SARAH TEW PHOTOGRAPHY

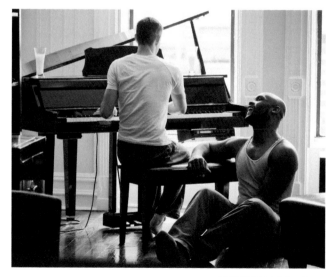

UNUSUALLY FINE

Engagements

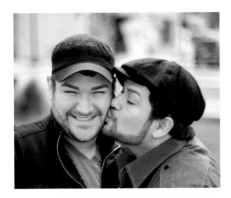

KATIE JANE PHOTOGRAPHY

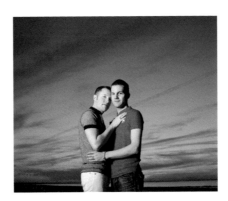

ARGUEDAS PHOTOGRAPHY

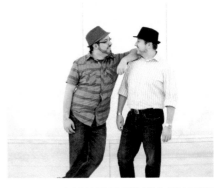

MEREDITH HANAFI PHOTOGRAPHY

ENDEARING KISS
This kiss is on our list because kisses capture love. Make it a kiss on the lips, on the cheek, or a shoulder. Know your couple and encourage them to keep it playful and spontaneous to show the authentic side of how they relate. This endearing kiss shares a little something about the personal side of each man without making the viewer feel like an intruder.

CROWD PLEASER
A common challenge for photographers who shoot engagements and weddings is meeting the expectations of both the client and the extended family. We advise a balance of style and simplicity to create a diverse offering to please everyone who reviews the gallery. Here, the men facing forward with heads touching shows a gentle yet simple connection and the sunset provides a stylistic backdrop without upstaging the couple.

CASUAL CONNECTION
Seasoned photographers will recognize this pose from the traditional wedding playbook for grooms and their best men. This casual, yet connected pose generally conveys a connection of friendship and support. In this image, however, the direct and meaningful gaze shared by the two men indicates a much closer, more intimate relationship.

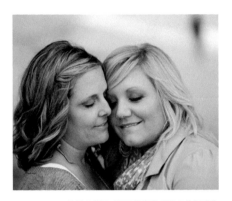
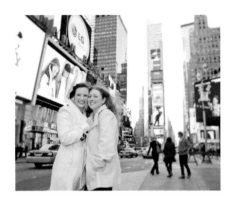
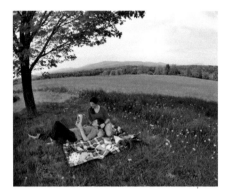

CHARD PHOTOGRAPHER

SEAN GALLERY

AUTHENTIC EYE PHOTOGRAPHY

NUZZLE

Nothing says love like a nuzzle. The challenge with a couple of the same height (often occurring for same-sex couples) is getting the couple close without covering up too much of their faces. Layering their bodies is key to solving this challenge. Guidance with phrases like, "put your shoulder into your partner's armpit," can reduce confusion so the couple can stay in the moment and focus on their nuzzling.

ARTISTIC TOUCH

Use the details of the surroundings as an advantage. Here, the chilly temperature is impactful and necessitates an embrace, introducing a feeling of rightness to posing cheek to cheek. The bright billboard ads and busy streets provide an artistic touch without the action overwhelming the couple.

CREATIVE COUPLES

Some couples will suggest a theme to the engagement session, like a prop-filled picnic, a meaningful location, or stylized outfits. These occasions provide a wonderful opportunity for the photographer because working with creative couples often leads to inspired images. To the extent possible, brainstorm with the couple in advance and be prepared to introduce some ideas of your own to help them connect more authentically with the session.

Happily Ever After

REPURPOSING NOTIONS OF ROMANCE

By underexposing the subject and exposing for a bright background, the camera loses the detail in the subjects and turns their bodies into a silhouette. It can be a wonderful effect, but as with most "effects," an over-reliance on the effect in a photograph can result in a neglect of the message. Not so here. Taken in the San Tan Valley Desert in Arizona, this image is striking in its composition, and clear message of strength and intimacy.

To communicate closeness, one might tend to rely on posing a couple physically close. Here is an inspired exception to the rule. By having these two men stand side by side—so far apart they have to reach a bit to clasp hands—the photographer has created perfect separation between their bodies without forfeiting the notion of their romantic connection. The contrast of the dark landscape and dramatic sunset completes the image, capturing more detail—a clear sense of rugged location, their masculine physique and muscle tone—than is commonly found in a silhouette.

The end result? We are invited to share in this breathtaking sunset, and the sense that this couple is taking in the moment: everything the end of a long day together should be.

TAMMY WATSON PHOTOGRAPHY

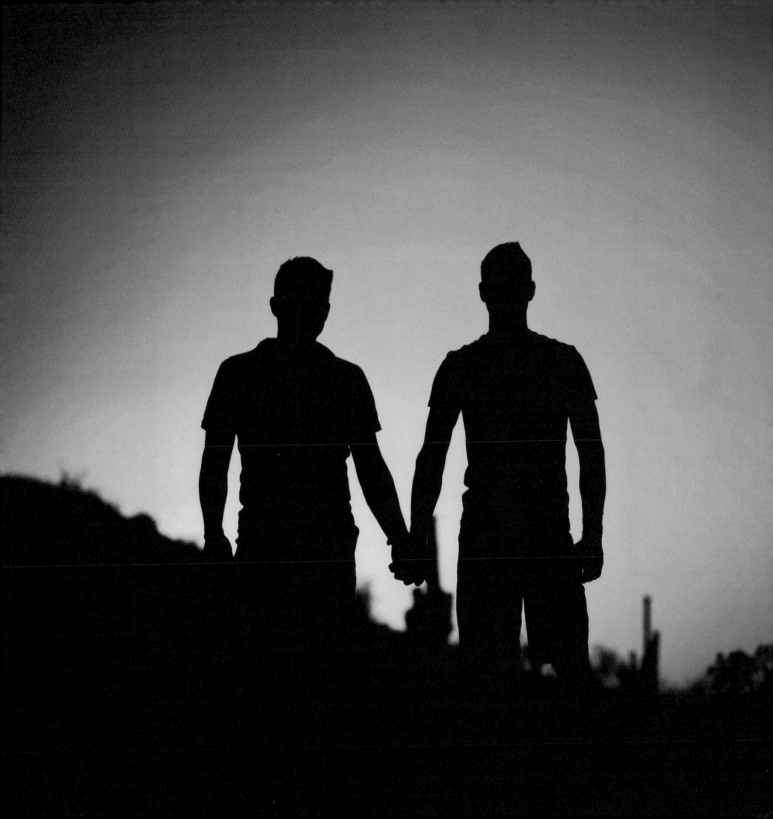

Timeless Love

SNUGGLE WITH A TWIST

BEHIND THE LENS

Maggie Winters loves to capture her couples without relying on Photoshop for embellishments or enhancements. "Though I shoot in color," she says, "I love to create black and white and vintage style images. I will not alter the contents of the photograph, other than to crop it. I believe that life is beautiful exactly the way that it is."

Photographer Maggie Winters takes this couple's portrait from ordinary to extraordinary by capturing the spontaneity and authenticity of their relationship while managing and mastering details such as stylized props and clothing.

Props can sometimes be a challenge to work into a portrait. Putting a suitcase between the couple could have been a recipe for disaster, but instead it forced the couple to point their knees away from each other creating a complementary angle with their legs and forcing them to twist their upper bodies toward each other. This is a complicated bit of posing that somehow looks believably natural for this lesbian couple.

MAGGIE WINTERS PHOTOGRAPHY

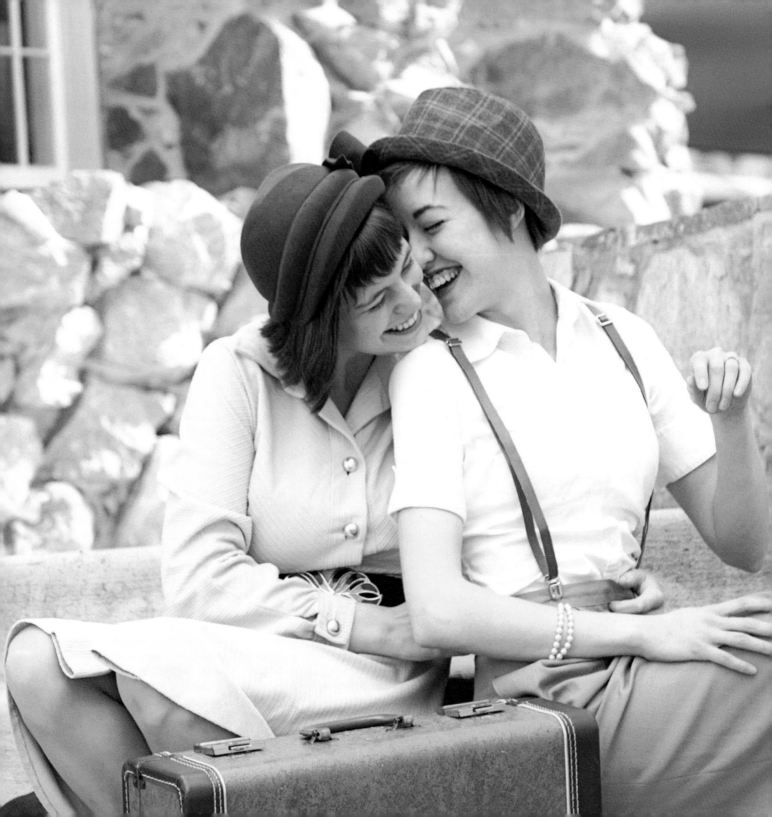

On the Boardwalk

THE VITALITY OF LAUGHTER

BEHIND THE LENS

To get a couple to behave "naturally" in front of the camera, have fun with them. A natural exchange between two people, captured in the moment it matters, can overcome almost any awkward pose, background imperfection, or other conceptual flaw.

Photographer Johnny Arguedas' style and familiarity with his subjects (and their comfort with him) is unmistakable. This unique image, taken at Sandy Neck Beach in Barnstable, Massachusetts, is a standout in a world of generic images of men shown in relationship to one another. Even the briefest glance at this delightful moment allows ample insight into this couple's individual personalities and the dynamics of their relationship.

Though the moment has been captured in a single frame, one can discern the fluid strength in the stance of and arm support offered by the white-shirted gentleman. The flirtatious laugh and unrestrained enjoyment of his partner is infectious and one cannot help but wonder what was just said to inspire such a reaction.

Though there are some consciously styled elements here—from the complementary white pants and white shirt to boardwalk lines and purposeful placement of the couple—the magic of this image is in the authentic joy captured in the moment between these two men.

ARGUEDAS PHOTOGRAPHY

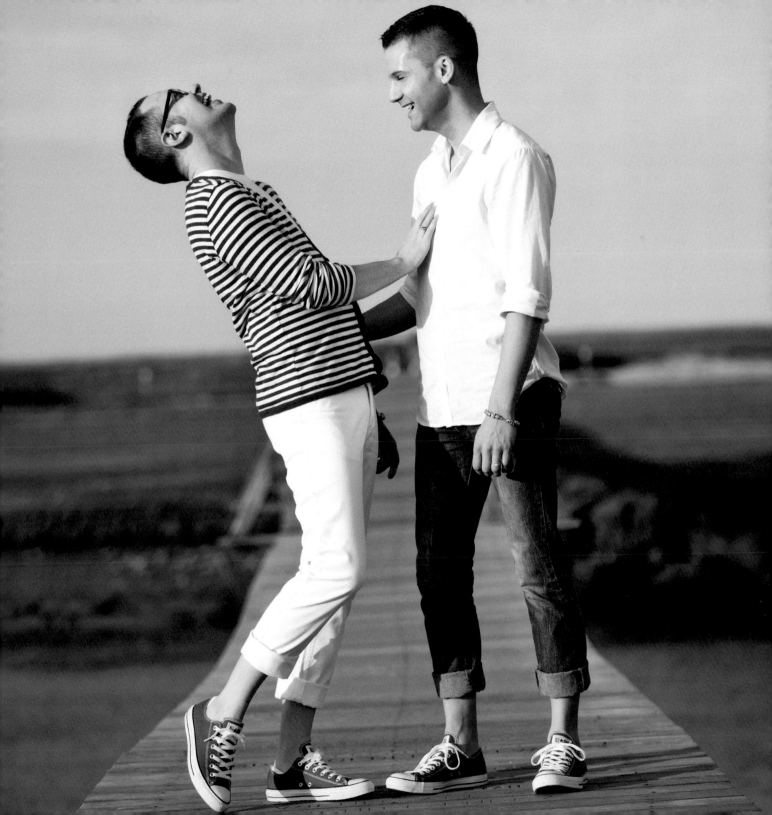

Fire Escape

IN HER ARMS

BEHIND THE LENS

Says the couple: "Maggie helped us feel comfortable in front of the camera almost immediately. We gave her a few basic ideas of what we wanted from our photos, and she was able to express exactly what we were looking for... We are goofy and up to try anything, and Maggie is as goofy as we are. She didn't hold us back at all—she encouraged us to try anything we thought up."

There was once a time when creating a professional portrait meant that the subject would be posed, looking directly at the camera. But, again, times have changed. The lesbian couple featured here may not be making eye contact with the viewer, but the essence of their love is explicitly represented. We are witnessing an authentic moment, an intimate exchange that is beautifully framed, rather than restrained, by the lines of the railing that surrounds them.

Though this pose looks effortless, there is a very clear attention to detail with hand placement. This is an important touch because hand placement impacts upper body posture. Because the woman in front has placed one hand flat one on top of the other, her upper body is poised at ease and her hands are not a distraction to the foreground. This also allows her partner to tuck in around her, using her waist and the railing to frame a natural embrace suggesting a balance, not driven by the Old Standard expectation that, in a layered pose, one person's position would be dominant to the other.

MAGGIE WINTERS PHOTOGRAPHY

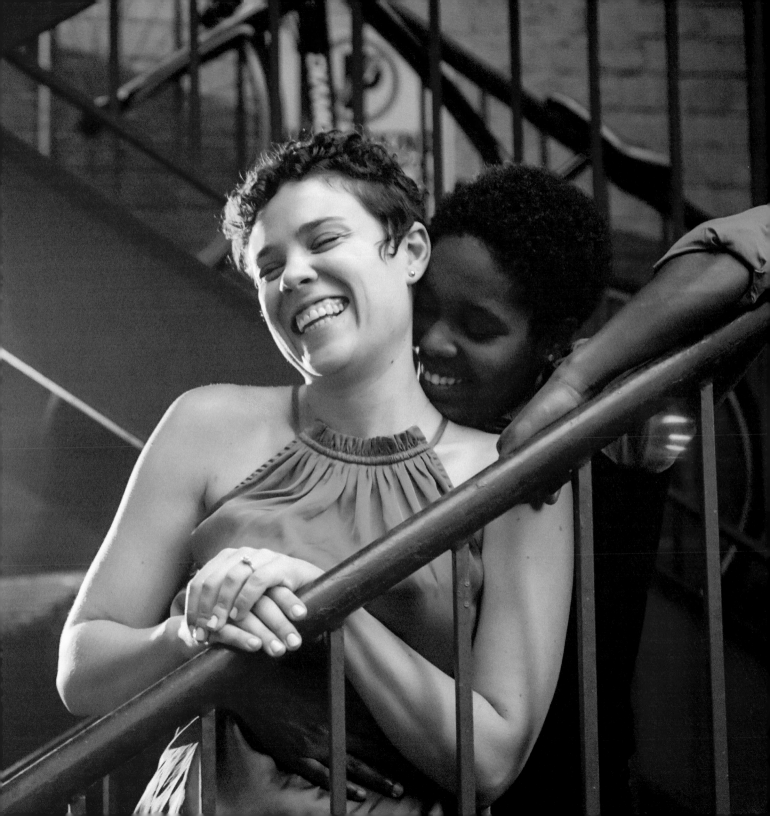

Southern Comfort

A VIBRANT AND NATURAL SIMPLICITY

BEHIND THE LENS

Avoid straight arms and be mindful of the length of a woman's arms if you are shooting a lesbian couple. This pose was originally intended for a man to wrap his longer arms around a smaller woman. To avoid a pose with overly straight or tense arms in a case like this, ask the woman in back to pull her partner in as close as possible and then ask her to hold her shoulders up and back while relaxing her arms.

Engagement sessions have traditionally been for young lovers. Not anymore. In the new frontier of same-sex engagement portraiture, a photographer might easily find him- or herself working with a couple who have been in a committed relationship longer than the photographer has been in the profession!

The message communicated in an image should reflect the stage and age of a relationship. A mature couple, for example, might be better captured in a pose that shows the ease of their comfort and familiarity with each other, rather than one imbued by the giddy, early days of love.

What might be referred to as the classic "prom pose" is reinvented here for this lesbian couple who selected the Fort Worth Japanese Gardens as a backdrop to commemorate their legal elopement to Vermont. Interestingly, this couple also had plans underway to host a "big wedding" with their friends and family back home in Texas, even though the second wedding would not be legally recognized.

LYNCCA HARVEY PHOTOGRAPHY

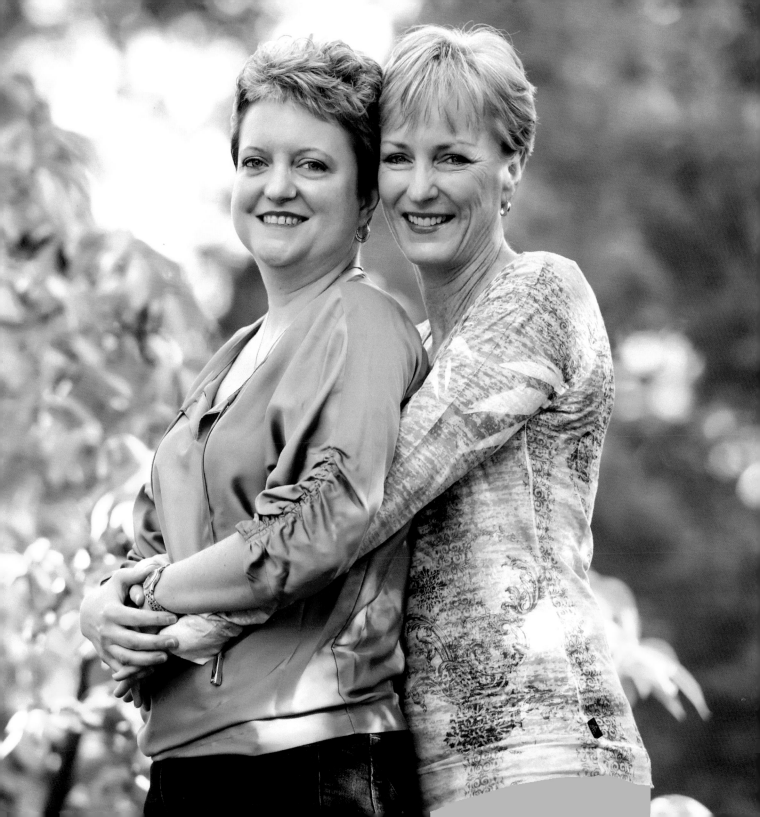

Saturday in the Park

LIFE UNDER ONE BIG UMBRELLA

BEHIND THE LENS

First designed in 1978 as a flag for a San Francisco gay pride march, the rainbow has become one of the most widely recognized symbols of LGBT pride. And it's safe to say that inclusion of a rainbow umbrella in a same-sex engagement session will strike an historical and playful chord for most, but be forewarned: not all same-sex couples will want to include rainbow symbolism in their celebrations and photo sessions.

The walking shot is an engagement and wedding standard because it allows the opportunity for a couple to look natural in a pose, regardless of gender or height difference. The pose also provides an opportunity for deeper insight: often, how a couple walks together can say a lot about their closeness and how they interact.

Many photographers have their couples hold hands, inviting them to, "Walk towards me." But here, the umbrella replaces the need for the couple to hold hands because the act of sharing it brings them together, providing a circle (the universal symbol of eternity) above their heads.

Meanwhile, these men are clearly enjoying this moment, as they walk openly as a couple down a city street—in an intimate moment, not a pride march—celebrating their spiritual bond and approaching legal nuptials. The joy of the moment is underscored by the bright colors of the umbrella and complementary yet contrasting colors of the couple's attire. The result is an image that sings with happiness.

KRISTINA HILL PHOTOGRAPHY

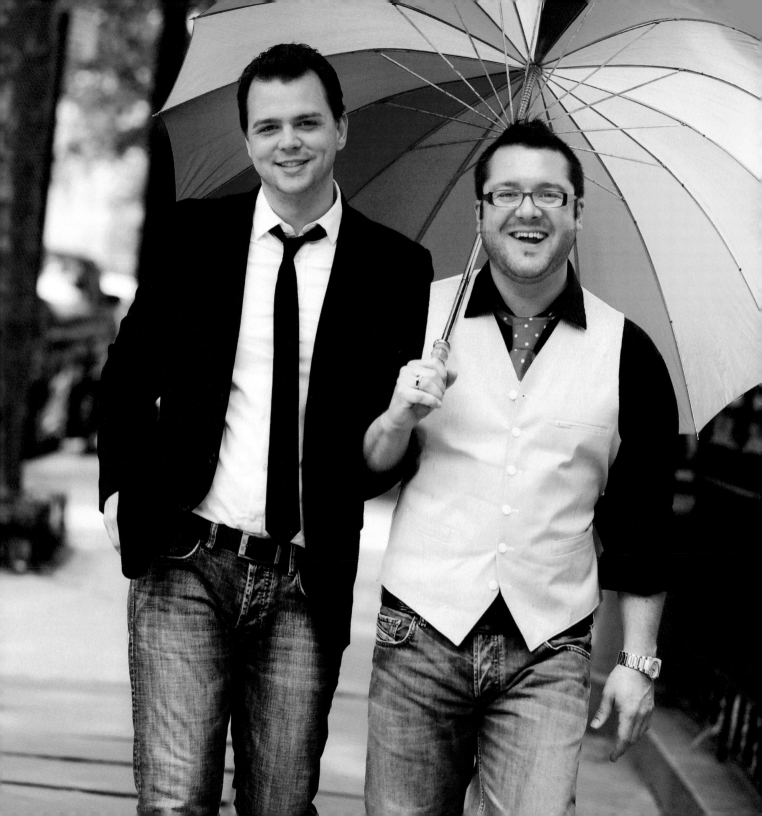

Seated Embrace

LAYERING WITH ORGANIC INSPIRATION

BEHIND THE LENS

When layering bodies, don't be fooled by attire choice. Just because one partner is in a dress, her (or his!) body type is not always best placed as the outermost layer. With same-sex couples, there is no one-size-fits-all solution. It is up to the photographer to observe the couple, better understand their relationship, and perhaps even think outside the box to find the pose most fitting for the couple.

The key to photographing a seated couple is by an intuitive layering of bodies. This creates a physical closeness that communicates emotional intimacy without making the couple look like they've been awkwardly or rigidly stacked according to a one-size-fits-all formula.

The obvious place to begin is by asking the person who is physically larger than the other to serve as the foundation. In engagement and wedding portraiture with opposite-sex couples, the woman *always* sits on the man's lap; to do otherwise is to suggest a punch line. Thankfully, with same-sex couples, photographers are not backed into this stereotypical pose; rather, one can pose by body type or personality rather than plumbing.

With subjects who are the same or similar size, it can be challenging to layer them without hiding one behind the other. Sidney Morgan solves this by asking each woman to sit closely, facing one another and turned slightly toward the camera. This creates a comfortable embrace for the couple, neither is hidden, and the seated pose removes height from the equation.

SIDNEY MORGAN PHOTOGRAPHY

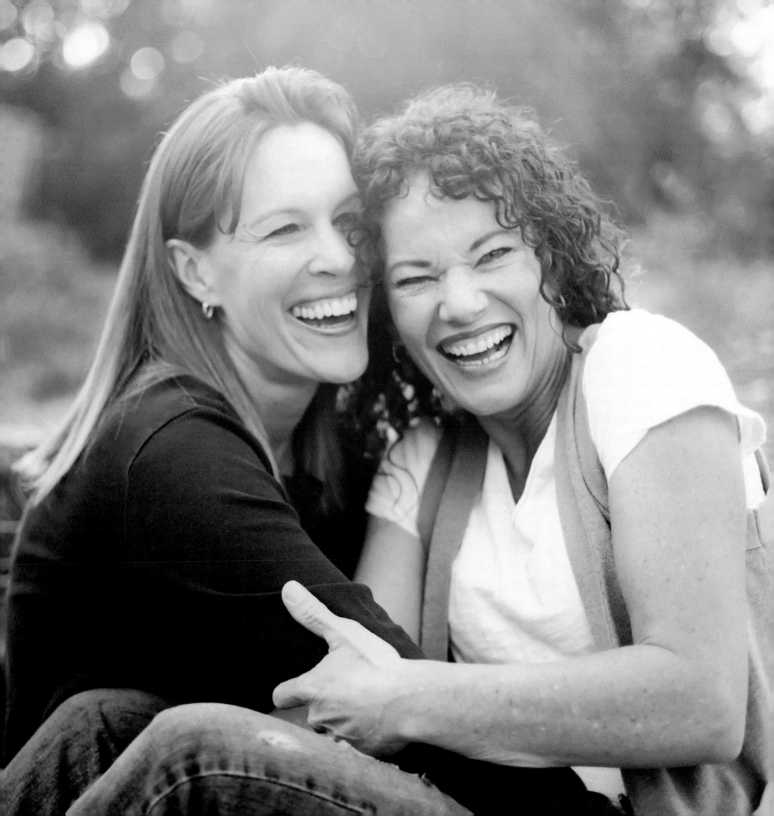

Bright Lights, Big Horizon

ROOFTOP WITH A VIEW

A photograph at sunset is dramatic because the light is soft and the sky is beautiful. But sunsets present challenging lighting scenarios because one must balance artificial light (to light the subject) with the bright natural light of the background. One must be careful not to overexpose the skyline and lose the details of the subject and colors of the sky. Instead, create a "modeling light" by keeping the artificial light off camera, allowing for gentle shadows and more natural looking light.

In art school, students are taught to deconstruct images, turn them upside down to look at the composition without being distracted by the message. Doing so with this image reveals an example of perfect lighting, exposure, composition, craft, and positioning. This image is visually pleasing and emotionally powerful.

This moment, as captured, tells us that the men are looking out toward a new horizon together, but the modern touch of the glass building with neon outline also suggests something of a new frontier for all of us.

Photographer Jeremy Fraser also does a nice job of finishing the shot with an attention to detail with his couple. In asking the *taller* of the two men to place his hand on his fiancé's heart, he adds a nice connection between the men, but also adds a subtle twist on the Old Standard theme of having the (generally shorter) woman place her hand on the man's chest.

CEAN ONE PHOTOGRAPHY

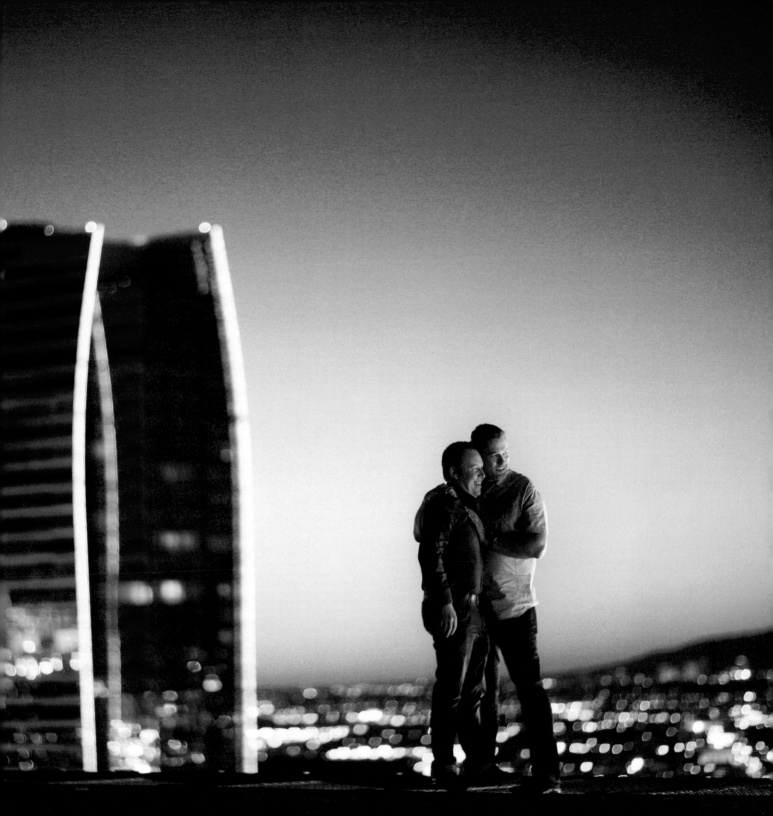

Same-Sex Weddings

WHETHER WE ARE TALKING about commitment ceremonies, religious ceremonies, civil unions, or a legal marriage ceremony, there are two universal threads woven into today's same-sex weddings. First, same-sex couples may lean on relevant rituals to guide their ceremonies and receptions, but they often turn wedding traditions inside out to create personally meaningful celebrations for themselves. And second, because marriage is not available to all gay and lesbian couples (and has only recently become available to some), same-sex weddings are considered something special; the LGBT community does not take for granted the right to marry. These two co-existing threads mean that same-sex weddings can be powerful and transformative for the guests in attendance, bringing a new understanding and appreciation of same-sex relationships.

The dynamism of emerging trends in same-sex weddings has had ripple effects for all involved, and a photographer needs to be aware of how prospective clients want to approach their weddings in order to be well prepared. Further, photographers should be mindful of how the involvement and emotions of the wedding party, family, and guests can be an integral part of the wedding story and provide a meaningful dimension to the wedding album.

Approach a planning session with an open mind; follow the couple's lead, but be prepared to offer guidance.

Tip: *Plan ahead to consider how details like attire, color scheme, or flower combinations for two brides or two grooms might impact the photographs. Choices may range from the traditional to the unique or from everything in pairs to complementary options.*

Tip: *Be prepared to photograph all kinds of unions—from formal, traditional religious weddings to casual elopements at City Hall. And remember that some couples may have more than one ceremony.*

Tip: *Don't assume that parents of the couple are certain of their role in the wedding or that they will be there. For some, this can be a delicate topic.*

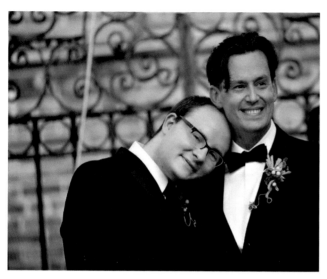

ARIELLE DONESON PHOTOGRAPHY

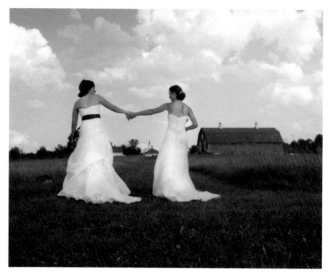

AUTHENTIC EYE PHOTOGRAPHY

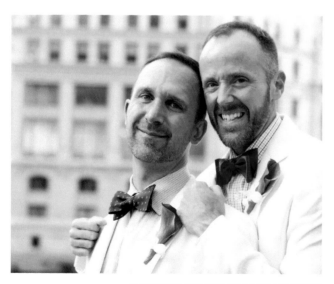

DENVER SMITH PHOTOGRAPHY

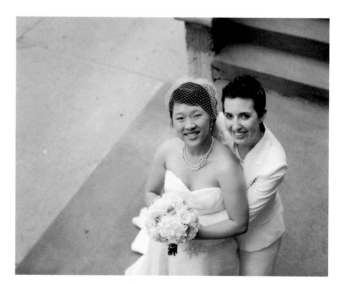

HUDSON RIVER PHOTOGRAPHER

Two Grooms

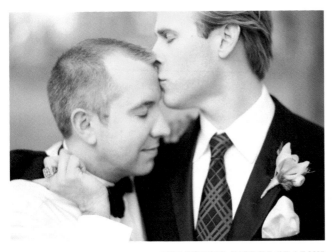

JEN LYNNE PHOTOGRAPHY

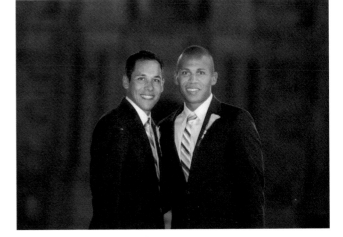

CHRIS HENSEL PHOTOGRAPHY

CONTRAST AND APPEAL

It can be challenging to create contrast and visual appeal when photographing two grooms in matching tuxedos or dark suits. Here, the simple request to have one groom hold his jacket over his shoulder creates a nice contrast between the men, and it allows plenty of room to play up the traditional wedding colors: black and white. At the same time, the slight difference in height is played to perfection with a thoughtfully posed embrace and gentle kiss to the forehead to finish this tender moment.

SHOULDER-TO-SHOULDER

Traditionally, a man wears a boutonniere on the left lapel, so it's important that a photographer consider how this accent appears to the camera. When standing in a classic shoulder-to-shoulder pose, one boutonniere is likely to be hidden. This can be an insignificant detail, particularly in a handsome image with two grooms like the ones here. But now that creative expression is common and the buttonhole more scarce on suit lapels these days, two grooms might want to reconsider boutonniere placement for maximum effect.

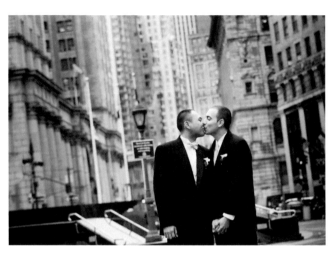

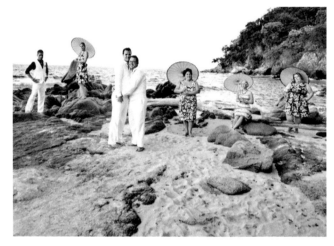

LESLIE BARBARO PHOTOGRAPHY

KRISTINA HILL PHOTOGRAPHY

DISPLAYS OF AFFECTION

Wedding couples are often photographed kissing in public. Even those couples normally averse to public displays of affection may be game for this pose on their wedding days. Even so, this pose doesn't always convey the love and connection it intends to symbolize. Enter two grooms—or two brides for that matter—and this pose takes on a whole new dimension. A same-sex kiss shared in a public space remains inherently powerful and meaningful, both as a symbol and reality.

WEDDING PARTIES

If there are two grooms, does this mean there will be two best men? Or two rows of groomsmen? Not necessarily. Same-sex couples often have mixed gender wedding parties, family as attendants, or no wedding party at all. Make sure to ask questions before the wedding about the wedding party and how the constellation has come to be. And when the Big Day comes, embrace the opportunity to be creative when photographing the group!

The Kiss

STANDING TOE TO TIPPY TOE

Jeremy Fraser says: "Cean's husband, Gareth, is a 'nugget,' and isn't tall enough to kiss Cean without standing on his tippy toes. Having witnessed it several times, we thought it would be a really cute way to capture something that occurs on a regular basis in an artistic fashion."

Photographers look for a moment that tells a story greater than the frame; a narrative that plays off of the visual cues in the photograph.

Photographer Jeremy Fraser captures the feet of these grooms in a way that communicates as much or more about the individuality of each man than a full body portrait might. Taken from this captivating perspective, Fraser directs the viewer to recognize that, from the variation in their polka dotted socks to the color of their trousers and the size of their shoes, these two men have a different, yet complementary, means of expression.

The pose offers an added measure of delight because of its ironic twist on the Old Standard, where the smaller woman must reach up on tiptoe to lock lips with her beloved. Thanks to our understanding of the whole of this classic pose, we are able, from only the parts given to us here, to surmise that these two men are very much connected—and romantically so.

CEAN ONE PHOTOGRAPHY

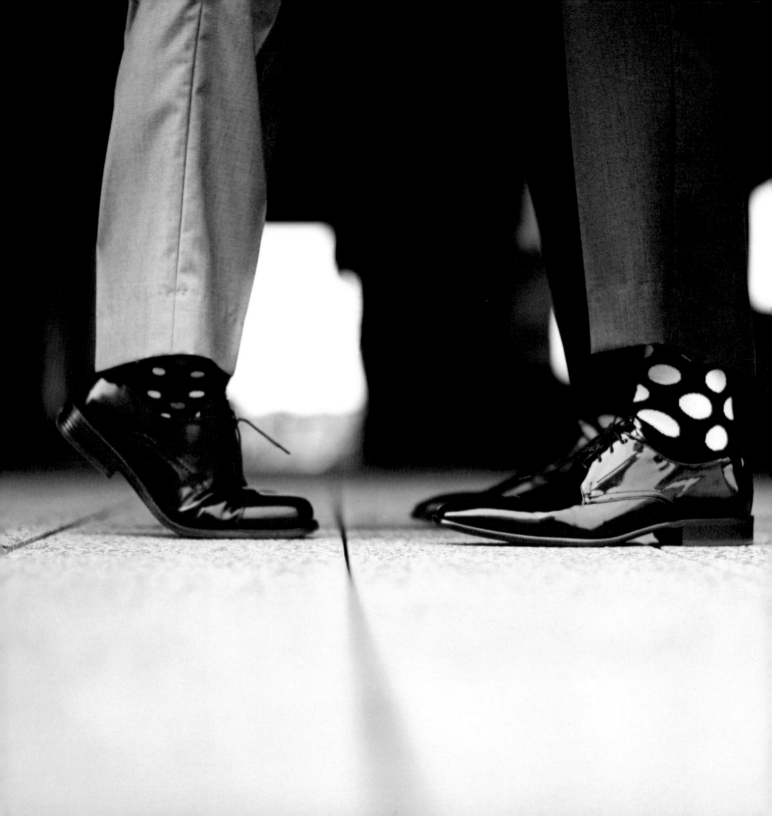

Blue Sky

SIMPLE JOY

When striving to take your photographs to the next level, you have to be your best critic in real time. Take a few stills and then ask the couple not to move or to talk amongst themselves while you look at the image on the LCD on the back of the camera. Consider all that is right in the image (e.g., lighting, emotion, body position), but then look more deeply at the pose for what is wrong and offer additional instructions to the couple from there to take the image to the next level.

It is common to ask a couple to face each other and wrap their arms around one another, pressing their foreheads together to seal the embrace. And there's no reason that this Old Standard can't work as well for two grooms as it might for one bride and one groom. This pose, however, will probably be most artfully implemented if there is a slight difference in height between the men, allowing one groom's arms to be more comfortably draped on the shoulders of the other.

What makes this image in particular so compelling is the simplicity of the embrace and the contrast of the blue sky. What might have begun as a self-conscious moment as the photographer directed this couple into a pose emerges instead as a genuine moment, punctuated by laughter and an intimate exchange. Even the fact that their eyes are closed seems to add to the authenticity of the moment, shared on this, their wedding day.

DAWN E. ROSCOE PHOTOGRAPHY

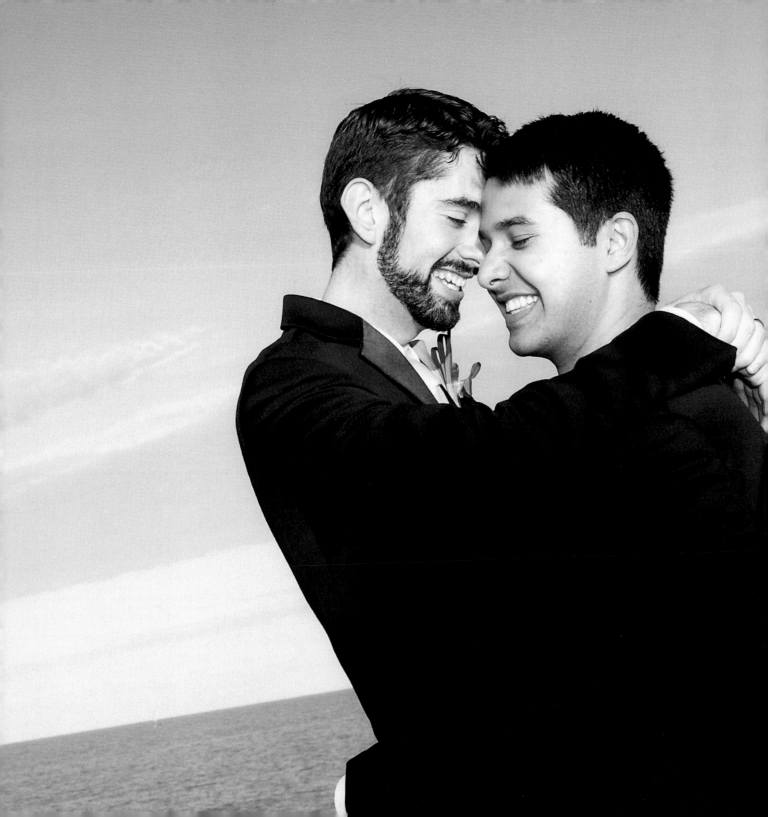

Marriage in Manhattan

A CITY SKYLINE

BEHIND THE LENS

During the planning session, talk with the couple about the personal (and perhaps even political) significance of special locations and other symbols they've chosen for the wedding and/ or reception. Consider the organic ways in which these backdrops or symbols might be incorporated into photographing the event, the wedding party, or the couple.

Long considered an iconic backdrop for wedding photos, the Brooklyn Bridge holds a special significance for these two grooms. This couple flew from their home in Texas to New York, where same-sex marriage was legalized in 2011, to tie the knot at the Carlyle Hotel in Manhattan.

In addition to hitting many of the marks of strong image composition—most notably with a confident use of lines directing the attention inward to the subjects—photographer Jen Badalamenti brings an added significance to this session. She invites the grooms to share a public embrace and commemorate their legal wedding day by choosing a location which not only highlights the city in which this couple has chosen to marry, but also echoes the historical significance and tradition of marriage in New York City.

Says Jen Badalamenti: "We met up a week before the wedding to do some portraits of (the grooms) around the city. Our session took us from Central Park to walking across the Brooklyn Bridge. It was an amazing adventure and one I will never forget.... I am so honored to have been a part this day and to know these amazing men!"

JEN LYNNE PHOTOGRAPHY

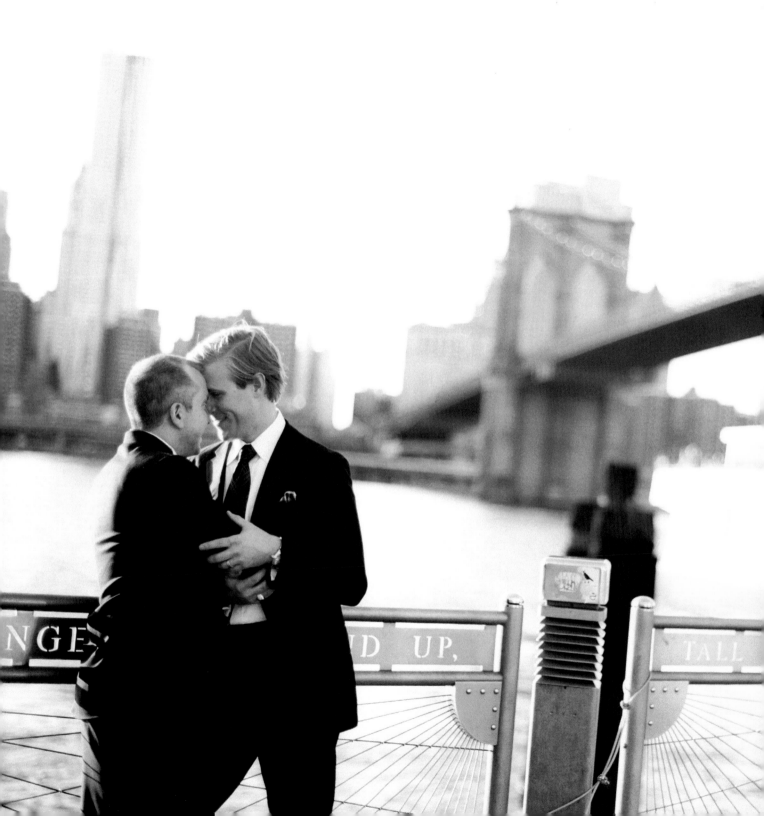

In Confidence

REFLECTIVE DISTINCTION

BEHIND THE LENS

Good engagement portraiture begins in an authentic place. For a portrait to convey warmth, warmth must be present. For a portrait to convey love, a space must be created in which the love can be present. If self-consciousness is the foe to authentic photography, then a photographer's ability to connect is its best friend. Filters and gimmicks may bring an interest to the end result, but they cannot invent authenticity if it isn't present.

Layering a couple with the taller of the two in the back is a long-standing and effective technique from the Old Standard playbook. Thus, this pose works more often than not because of the difference in body type often present for heterosexual couples.

Notice here, however, that this gay couple has both a significant difference in height and shoulder width, and as a result, their different body types layer naturally in this traditional pose. As such, there is no need to re-invent this pose for them.

But don't stop there! Move the application of this pose from the Old Standard playbook to one that "sees" the subjects as they are—of the same gender and in love. To do so, position the couple in a visually pleasing way, and then create a "private" space and nurture a sweet moment into being for them in order to capture how the couple relates to one another, just as photographer Jimmy Ho does here.

JIMMY HO PHOTOGRAPHY

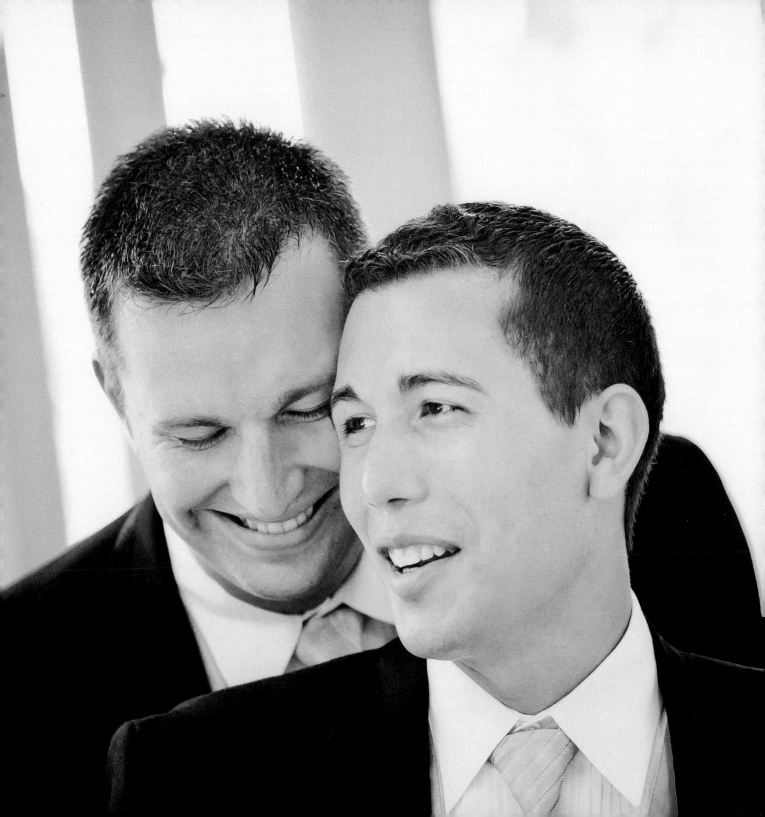

Contentment

THAT PEACEFUL, EASY FEELING

BEHIND THE LENS

Says Jody Webster Holman: "I shoot in an editorial style, using natural light whenever possible, rarely asking for or creating a posed situation. This moment was organic, which I hope, shows. We spent the day in Sonoma venturing from one winery to another, tasting, touring, chatting, and just enjoying the day. At one of the wineries, the couple met up with a friend who performed a short ceremony for them. It was near the end of the day, with great light at a warm, lakeside spot...and it was a truly, heartwarming moment seeing these two just enjoy each other."

Many of the couples in this book have been posed in variations of poses that are tried and true for heterosexual couples. Not so here. This pose offers us a new example of connection and "couple-ness" without relying on the customary playbook. In fact, this pose is one that would likely be best used for same-sex couples rather than opposite-sex couples.

Photographing couples who are the same or similar height and body type can be extremely challenging. This unique pose allows for two men (or two women) of the same height to layer their bodies without blocking each other. Further, the act of leaning upon one another adds a nice touch of interdependence. In this example, the simple gesture of the man in the light-colored shirt resting his head on his husband's shoulder turns this moment from one staged in the camera's eye into one imbued with sweetness and authenticity.

HOLMAN PHOTOGRAPHY

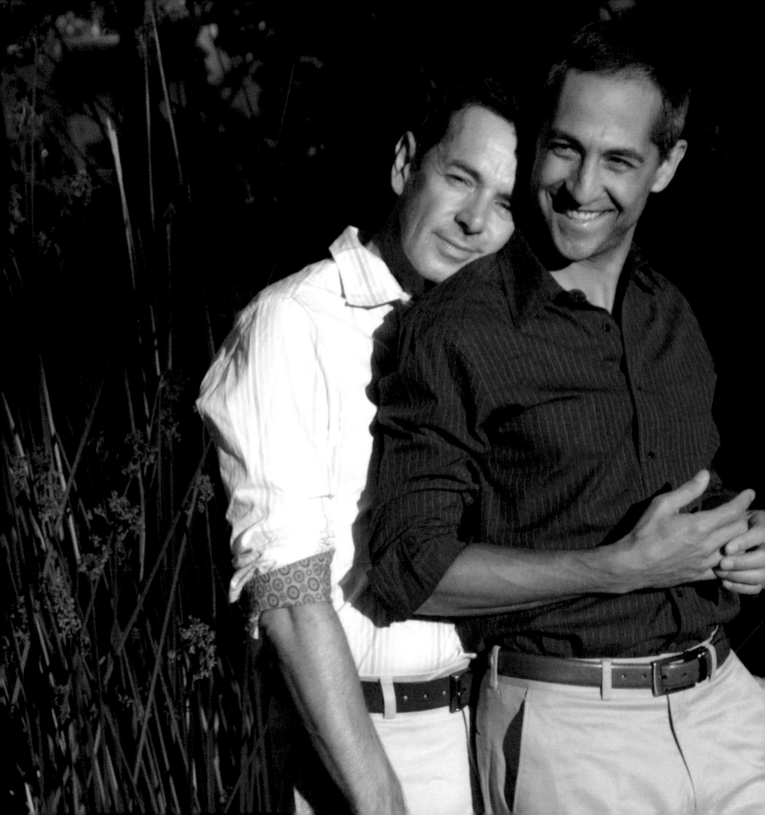

Fashion Police

FLIP FLOP FAUX PAS

Says Steven, groom and tailor: "Becky had just flown in from Virginia to be in the wedding; she came to my house the morning of the wedding so I could hem her dress. She brought her shoes for the fitting, and left them. We did not realize she had left the shoes until we were at the Hard Rock getting the pictures taken. Luckily, someone was able to stop by our house and bring the shoes to the church!"

With an image that is so full of commentary, it seems superfluous to say anything more. What person of taste wouldn't be mortified to see a member of the bridal party wearing flip flops on the Big Day? This gag shot (no pun intended) is a great example of how humor and playfulness in group dynamics result in fun and unique photos that add diversity and authenticity to the wedding album.

Though this group showcases a contagious and light-hearted moment, one finds even more to love upon discovering the backstory. Proving that indeed, fabulous is as fabulous does, these grooms didn't just plan the wedding of their dreams, they practically built it from scratch. One of the grooms made the dresses for the female attendants, as well as the two tuxes for the wedding. Respect!

BRIAN PEPPER & ASSOCIATES

Two Brides

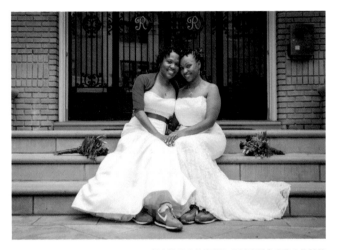

KAT FORDER PHOTOGRAPHY

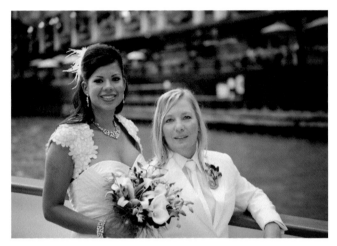

MAGGIE RIFE PHOTOGRAPHY

BOUQUETS

With two brides, you might have two bouquets for one couple, and large bouquets can be an obstacle when creating physical closeness in an image. Photographer Kat Forder had her brides lay their flowers aside so they could get close. The result? A classic wedding pose with a playful, color-infused twist.

CONSIDER THE COUPLE

The Old Standard dictates that the man should stand behind the woman when posing in a layered way. Head's up! Just because one bride wears pants and the other wears a dress doesn't mean that the bride in pants should be posed as a heterosexual man would. Consider thoughtfully the couple in front of you—their physical expressions and traits—and then apply them to a pose suited for them, not someone else.

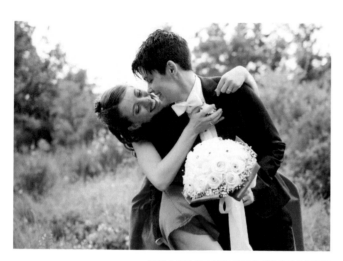

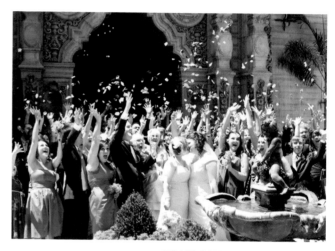

REACTION

If the first part of creating an amazing portrait is posing a couple, then documenting the couple's reaction completes it. Photographer Julian Kanz gets an excellent reaction out of this couple by adding a little twist to a common pose. And bonus! What's not to love about the touch of the woman in pants holding the bouquet?

COLLECTIVE EMOTION

Group shots at same-sex weddings have the potential to create a significant emotional impact; these are the images that show family and community support for the couples' unions. Often celebrating personal and political milestones, these photographs can capture viscerally the strong emotions present at same-sex weddings now that states have begun to legalize same-sex marriage.

Taking a Stance

WHAT THE SOLE HAS TO SAY

When photographing a couple's feet, ask them to do something interesting with their toes. Unless the combination of shoes speaks for itself, get creative! A straightforward shot of feet isn't nearly as interesting as the one that shows a little personality in the pose.

When the upper body is cropped out of a shot, one is left to wonder about the parts left out of the frame. Thus, the feet must speak for themselves to make an image of the lower body work. In this example, the simple act of having the bride on the left cross her legs feminizes what might otherwise have been an androgynous stance. Nothing wrong with either, of course; the question is which stance best reflects the couple's personality. And if the photographer hits this subtle mark, he or she will provide a compelling image that unveils details unique to each person's personality, all without relying on a facial expression.

EMILY G PHOTOGRAPHY

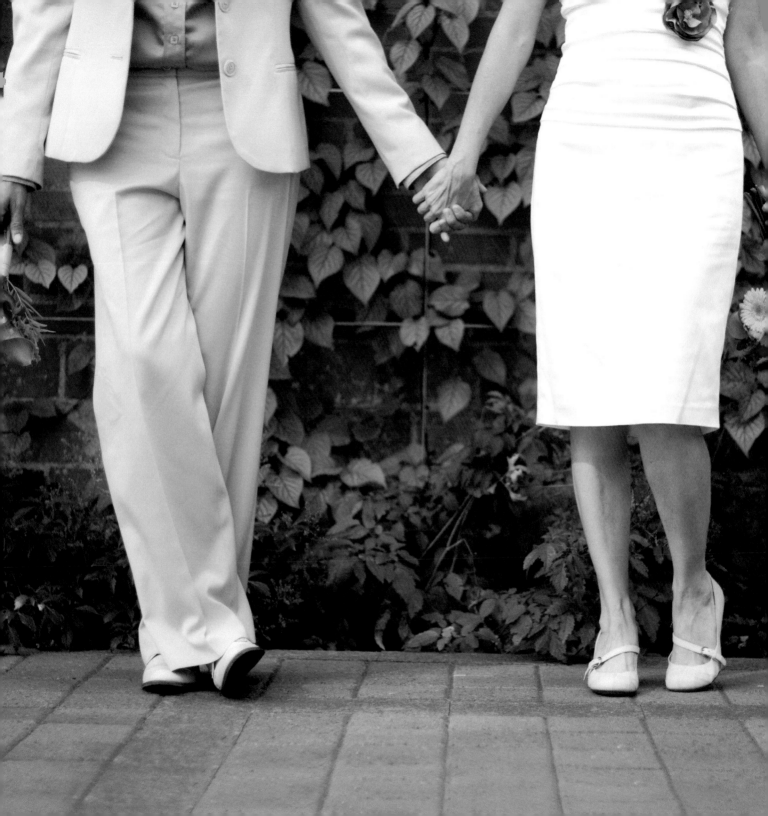

Tradition

MODERN VOWS, RUSTIC SENSIBILITIES

Says one of the brides: "Two of our good friends have been partners for many years and they grew up in a time when coming out and celebrating your love amongst friends and family was not as openly accepted...They may have had the best time at our wedding. On multiple occasions one of them came up to us saying how important the day was. She was blown away by the incredible feeling of comfort and acceptance that everyone there had not only for our relationship, but also for all of our gay and lesbian friends who were in attendance...it truly was one of the favorite parts of our day."

As we've discussed, applying a traditional pose to a same-sex couple is not always advised. When used thoughtfully, however, doing so can work beautifully and highlight the authenticity of the moment and relationship of the couple.

These two brides planned a traditional, white wedding with all of the trimmings at the Webster Barn in Vermont. In keeping with their rustic theme, they rented an antique truck to serve as a lemonade stand for refreshments. Photographer Thea Dodds applied this traditional pose—with one partner sitting on the lap of the other—and it works for this couple because of their body types, personalities, and comfort with public affection. With the interplay of the stunning mountain background and the thoughtful details of the brides' rustic wedding theme, posing them on the back of the beautiful antique truck was a perfect choice and the result speaks for itself.

AUTHENTIC EYE PHOTOGRAPHY

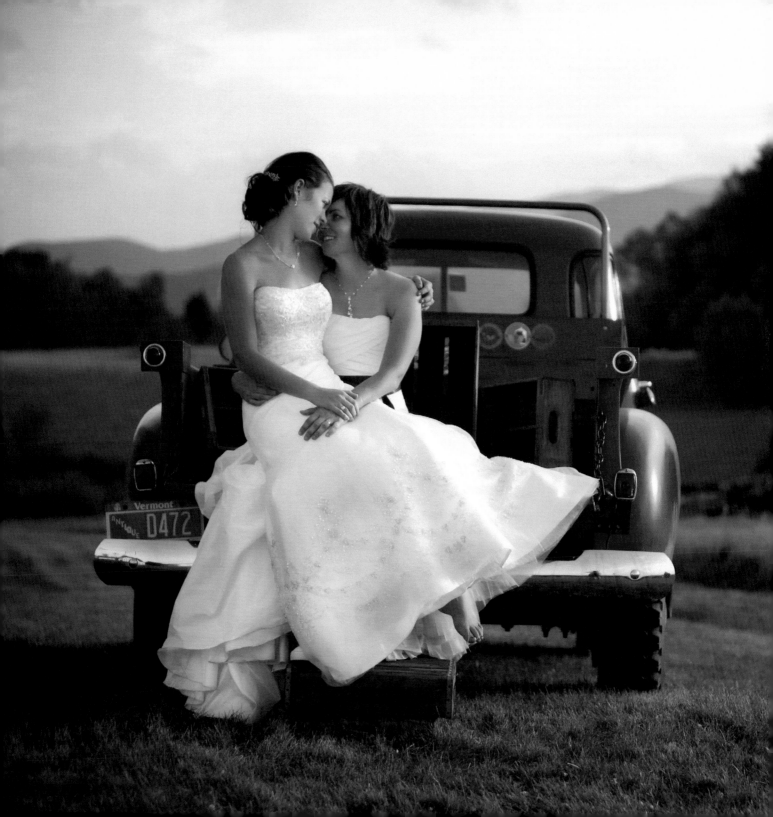

Lightness in Love

A TOUCH OF THE VEIL

Reminding us that spontaneity and timing can go hand in hand, Allana Taranto describes capturing this image as a "happy accident." She says: "I asked the brides to walk up to the bridge. I was visualizing a very different image, but there were too many people walking through the frame, so I moved a little and found this lovely angle of simplified architectural elements of the bridge itself. The wind picked up and once the arm went up to catch the veil...lyrical!"

Photographer Allana Taranto found a unique angle with which to compose this engaging moment, creating an absorbing work of art for this couple's wedding portrait. She hits just about every mark of the Old Standard (as discussed in the Background section of this book), but does so in a way that is modern and fresh. She utilizes a unique perspective (the "ant's eye" view), her subjects' arms frame their faces (a frame within a frame), and she tilts the camera to accent the angle of the railing, creating visual tension. The result? A one-of-kind image that represents these two brides just as they are in this private moment on their wedding day.

ARS MAGNA STUDIO

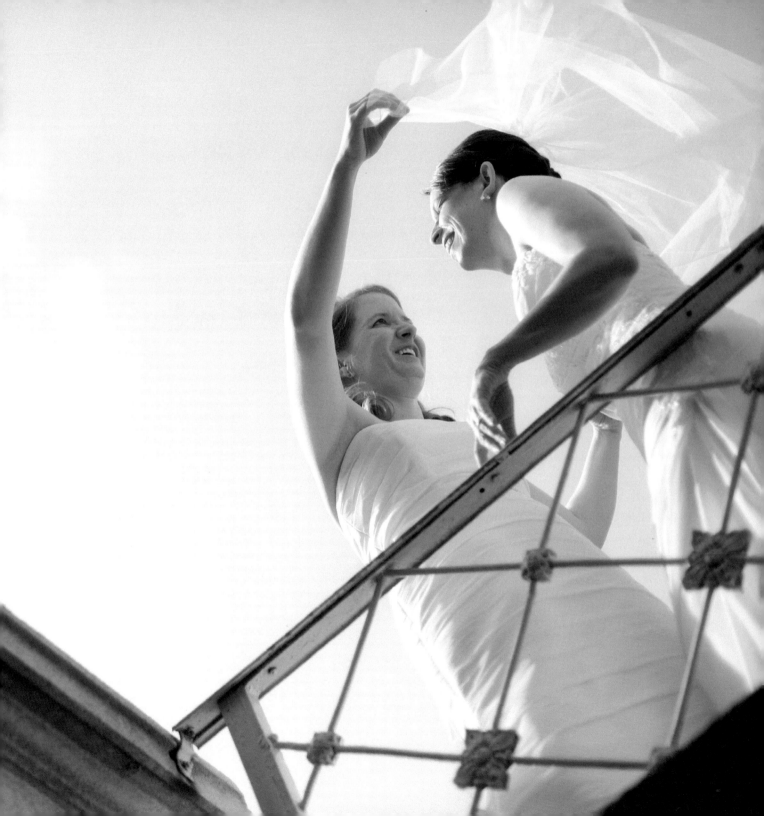

Conveyor

PUBLIC SPACES, DELIGHTED FACES

Says Maggie Winters: "I got off first to photograph them all hanging out together on the escalator...and then a huge gust of wind came along and blew Jacqueline's dress everywhere. It was a totally spontaneous, hilarious moment that is a great representation of the whole day: fun, lighthearted, and adventurous, and filled with love."

Jacqueline adds, "I spent the first half of this escalator ride worrying that Maggie was going to break her neck, riding down backwards, and then all I could worry about was not flashing D.C. I am so glad she captured this shot—it shows how unpredictable and entertaining our whole wedding day was."

Taken on a Metro escalator in Washington DC, this image represents so much of what every photographer strives to create in his or her work: something meaningful, something fun, and something unique. The icing on this proverbial wedding cake, though, is that this photograph inspires a dialogue as it hints to a story outside the frame.

On initial glance, one feels the rush of joy captured on the faces of these two brides and their wedding party. With a longer look, however, one can't help but wonder what is going on off-camera. What is this group reacting to? Is it the pure excitement of their Big Day? Is it the gust of hot underground air? Did the photographer say something amusing?

At a time when anyone can take a simple picture with a smartphone, professional photographers must focus on what separates a snapshot from a professional image. Dialogue, mystery, and message are just a few characteristics that take this photograph from a simple shot to a skillful image.

MAGGIE WINTERS PHOTOGRAPHY

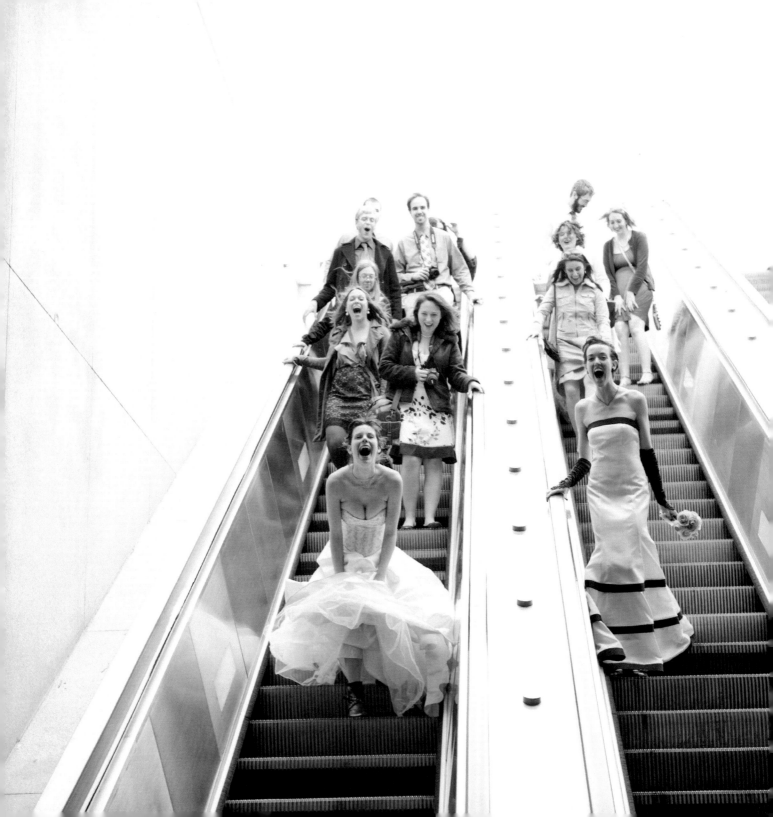

Touch

IN THIS MOMENT, FOREVER

BEHIND THE LENS

Do not mistake this pose as one that is easily accomplished. It can be incredibly difficult, if not impossible, to get one's clients to demonstrate the posing skills worthy of a professional model in the short few hours in which one has to work with them. A few simple, specific, and well-timed instructions can help the couple look more natural in what can be a self-conscious moment for some.

This pose offers another excellent solution for working with a couple of similar height. With one bride sitting sideways and the other crouching behind her, square to the camera, this couple's bodies are naturally layered, and the slight height difference sets the frame for the finish.

In this case, photographer Ann Walker took a beautiful moment and transcended it with purposeful hand placement by asking the seated bride to place her hands ever so gently on her wife's chin. The contentment and intimacy between these brides in this moment is as palpable and powerful as it is gentle and sweet.

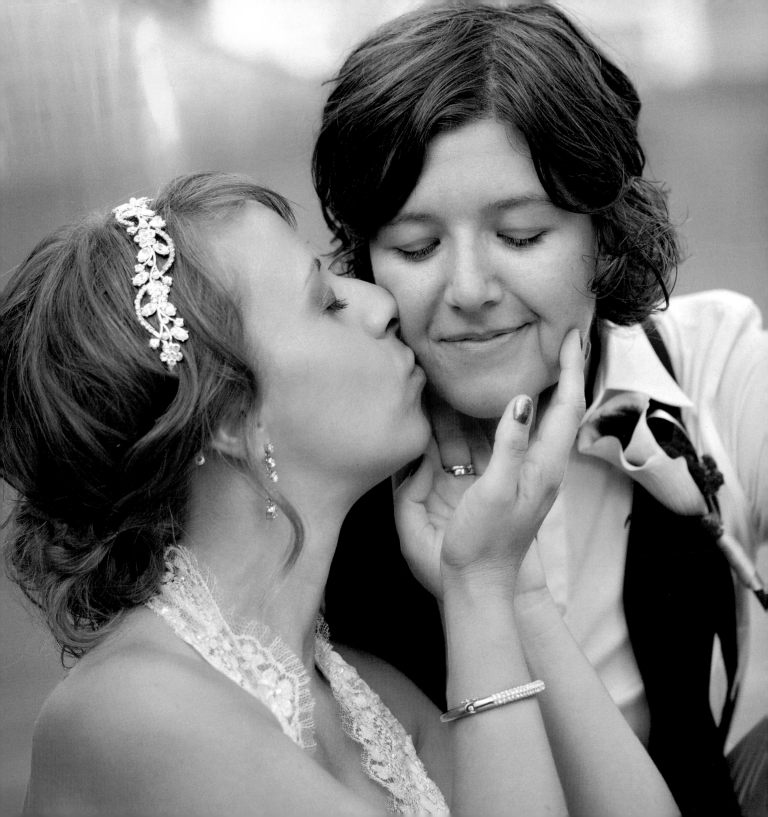

Gender Bender

A LITTLE DIP'LL DO YA

There are many things a woman can mean by the simple act of wearing pants; avoid jumping to quick conclusions and do not assume anything about the attire a couple wears and what it says about each person's gender identity or sexual orientation. Get to know the couple first and then begin to apply a few pose adjustments to bring a voice to those traits you have come to know as you come to know them.

There is so much play on tradition in this image: from a red wedding dress that one might expect to be white; to a second bride in black pants and white shirt; to a formally outfitted couple in a natural landscape where a woman in a dress is dipping a woman in pants. This image has much to say about this couple: their taste, their playfulness, and their strength as a couple.

Generally speaking, dipping shots should be attempted with care, especially if neither partner has a clear strength advantage relative to the other. No one wants to be the reason a dip collapses! This photo, however, contains a beautifully designed trick to prevent a dip disaster. Look closely at the wide stance taken by the woman in the red dress for balance and leverage. It's a pose that works because of the delight we experience in seeing a bride in a gown dip a bride in pants, but also because the gown hides an otherwise wide, awkward stance, essential to making this pose work.

JULIAN KANZ PHOTOGRAPHY

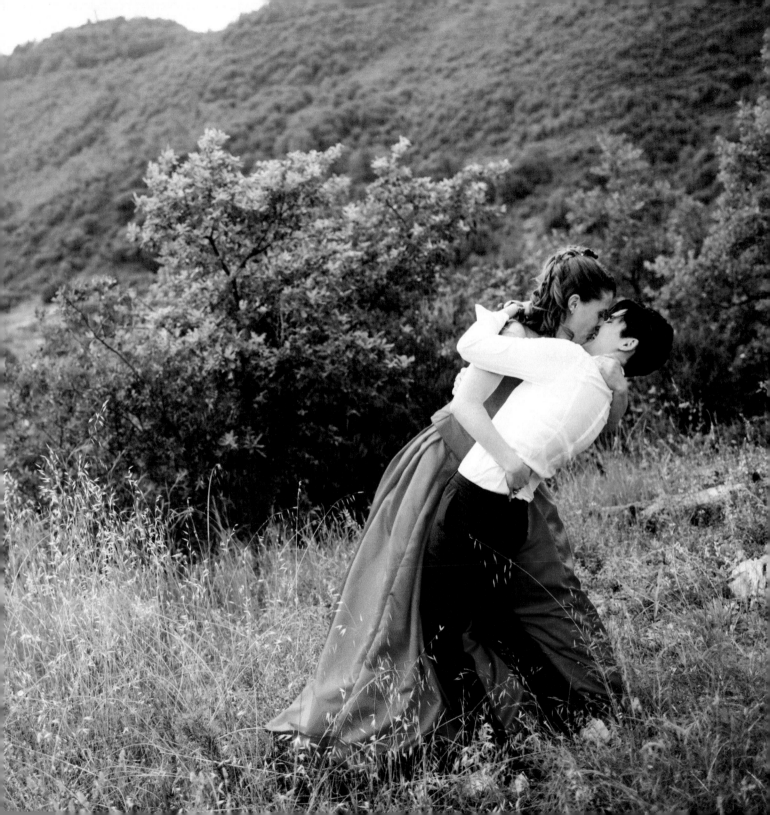

Love and Light

A BRIDAL SEASCAPE

BEHIND THE LENS

Many non-photographers may not know that white is actually one of the hardest colors to photograph. Because it reflects light so well, photographers often are forced to over-expose something white, which means details in the clothing may be lost. Add to your pre-portrait consultation a brief discussion about clothing color choice. Solid colors are best; avoid stripes and logos. White is okay, but other colors are better. So, if a couple is interested in breaking the wedding mold, wearing something other than white in a case like this might be practical and inspired!

It's easy to appreciate this super sweet, super cute, and intensely personal moment of love just as it is. But it's also worth noting that the moment that Torie McMillan has captured has emerged against many odds. Photographing two brides dressed in white, embracing in the bright sun with the ocean—surely the biggest reflector on the planet—as the background, is a really tough scenario. But here, Torie turned that brightness into an asset rather than a deficit, capturing an exchange between her newlyweds in a way that seems bright, cheery, and hopeful. Exactly as any start to a lifelong commitment should be.

Beyond managing the challenges to a seaside setting, this image benefits from impeccable timing. Rather than showcasing the standard newlywed kiss, Torie revealed a new dimension of intimacy between these women, showing us just how much sweeter the moment before a kiss, with its sweet nothings quietly exchanged, can be.

TORIE MCMILLAN PHOTOGRAPHY

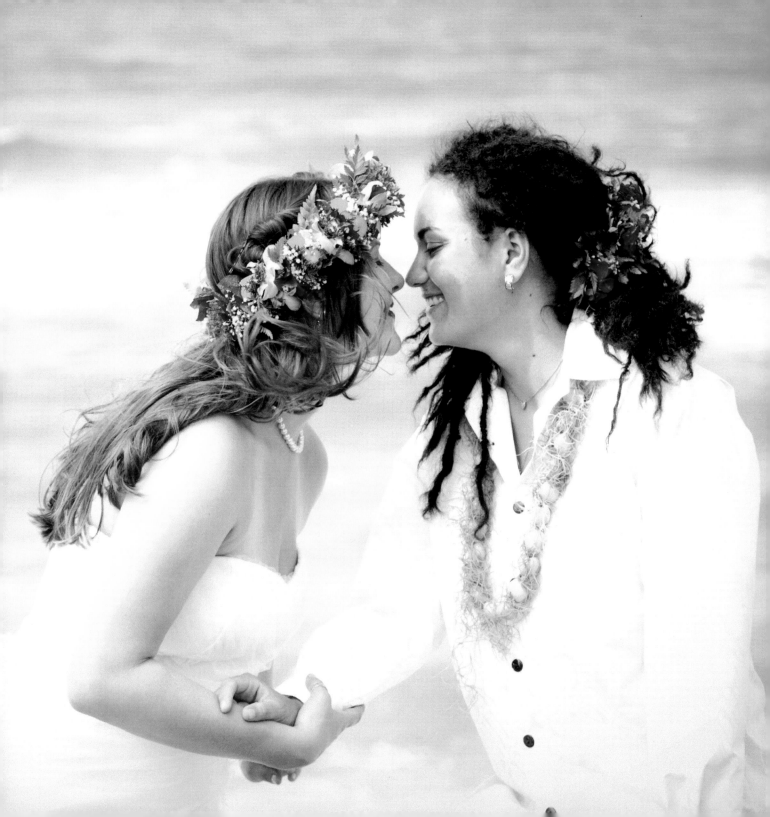

Communion

HANDS CLASPED, OUTSTRETCHED

BEHIND THE LENS

Ann Walker explained: "We were fortunate enough to have a lot of time for group photos since the ceremony was at sunrise, and the reception would not be until the evening. We decided to take full advantage of this rarity in wedding photography, so as our photo posing progressed to the wall (at North Avenue Beach in Chicago) and everyone was standing next to each other waiting for further direction, it only seemed natural to have them hold hands since they were standing so close to each other as it was."

In wedding photography, group shots are generally obligatory and often overly posed or dryly composed, but this does not have to be the case! Chosen for our front cover, this striking image by photographer Ann Walker offers the simplicity of a horizon and the steadfast strength of community. And this, we contend, is one of the true opportunities available when working with same-sex couples.

From a blending of attire styles—with a purple jewel tone being the primary requirement for the wedding party—to the flexibility for each person to choose the outfit style he or she deemed most comfortable, this gender-blended wedding party shows unwavering unity even amidst its clear embrace of individuality.

One of the brides, Dawn, expressed her thoughts about the image this way: "We are very grateful to have people around us who are supportive and unconditionally loving, and this photo does a great job of depicting this. Our wedding would not have been as magical as it was without everyone who came to stand by our side and witness our commitment to each other."

IT'S BLISS PHOTOGRAPHY

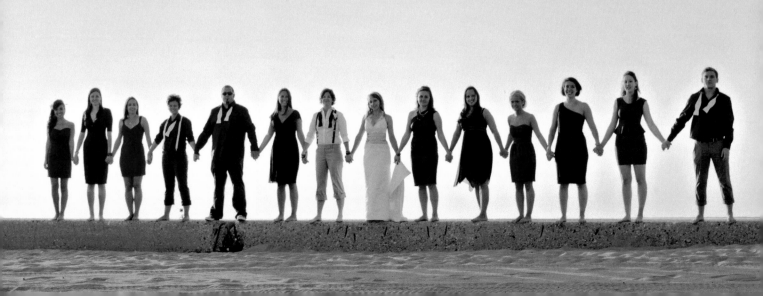

Declassified

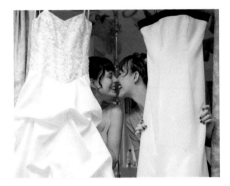

MAGGIE WINTERS PHOTOGRAPHY

HUDSON RIVER PHOTOGRAPHER

AUTHENTIC EYE PHOTOGRAPHY

GOWNS

How photographers will capture the many versions of same-sex wedding attire remains to be seen. Photographing a dress and a tux combination without two women wearing them is beside the point. But two dresses? The point is made even if the brides aren't in them. In either case, get creative; there's always more fun to be had, as seen here with this clever idea used to spice up the obligatory "dress" shot.

MAKE IT A DOUBLE

Yes, two brides may mean two bouquets, which may in turn mean a double bouquet toss. A lesbian wedding might also have two garters. A gay wedding, two cigars. Of course, none of these things may be true, either. Best practice: Don't assume. Ask.

FAMILY

A wedding is as much about celebrating friends and family as it is about a couple solemnizing a lifelong commitment. To be sure, it's an emotional experience for any parent to see a son or daughter walk down the aisle, especially one with its own "coming out" backstory. Don't neglect the opportunity to include the emotional responses of biological and chosen family during the moments that count at the ceremony and reception.

ARIELLE DONESON PHOTOGRAPHY

JEN LYNNE PHOTOGRAPHY

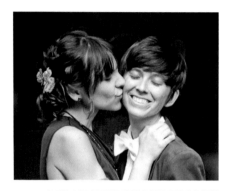

SARAH TEW PHOTOGRAPHY

DETAILS

Detail shots offer a chance to capture the symbols and subtle touches of a wedding. Photographing a groom's cufflinks comes straight (ahem) from the traditional playbook. Here, that classic shot is reinvented by illustrating the point that this is a gay wedding. Photographers can also play on the grooms' pairing of ties, shoes, boutonnieres, wedding bands, cake tops, pocket squares, and doting mothers!

NO GOWN? NO PROBLEM!

Suits (not to mention grooms!) are often relegated as bit players at straight weddings; traditionally, an overabundance of energy and emphasis is put on the bride and the almighty wedding gown. No gown? No problem! A wedding without a gown provides the chance to give two suits the royal treatment.

LGBT-FRIENDLY

When photographing any couple, start by meeting them where they are and as they identify. The LGBT spectrum is as wide as it is vast and each label means a little something different, and each couple you meet might have a different take on it. Educate yourself on common themes of the LGBT experience, and know that LGBT couples seek photographers who are seasoned professionals who will also wholeheartedly embrace the joy of their wedding celebrations.

It's a Wrap

TO SUGGEST THAT IT'S POSSIBLE to summarize and conclude everything about same-sex engagements and wedding photography is probably a bit misguided. We are, after all, bearing active witness to a time when history is being made before our very eyes; in the span of a decade, popular opinion polls have shown a dramatic increase in an acceptance of marriage equality, and wedding ceremonies that were once taking place "off the grid" (if they were taking place at all) are now having an influence on the mainstream traditions from which they were once excluded.

It is possible, however, to stop, observe, and recognize what is taking shape in wedding traditions while evaluating what hasn't been working and what can be improved. Photographers have an amazing opportunity to break new ground and establish new precedent when capturing love—from same-sex weddings to family portraits and anniversaries. And similarly, couples have the opportunity to help the wedding industry rethink its assumptions about who is getting married, what that should look like, and what the meaning of family—chosen, biological, or otherwise—truly is.

This is, after all, the new frontier of weddings, one inclusive of all couples of all shapes, sizes, ages, ethnicities, religions, and orientations. It's a frontier where the only requirement is a public declaration of lifelong love. And it's a frontier where the families and friends of same-sex couples continue to be powerful allies, settling for nothing less than marriage equality. As a photographer, you're standing at the edge of this promising frontier—capturing love and history with each click of the shutter. Enjoy the journey!

• • •

Have you experienced a Capturing Love breakthrough or want to recommend a tip or pose? Tell us about it! Submit your tips and portraits at www.capturingloveguide.com.

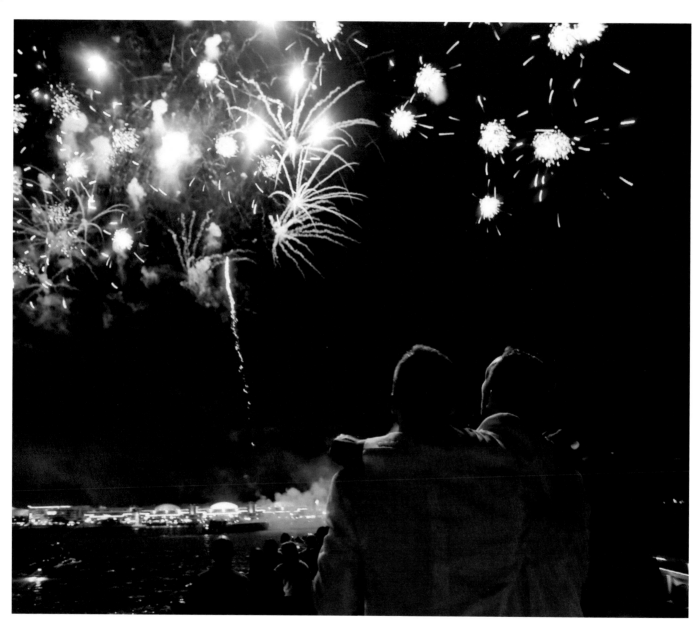

Glossary

Bisexual: A term defining one's sexual orientation, describing a person's romantic and/or sexual attraction or behavior to members of both sexes (i.e., a woman who is attracted to both men and women or a man who is attracted to both men and women).

Chosen Family: A term frequently used by the LGBT community to refer to a family unit that has evolved as a result of closeness and choice rather than biology.

Gay: A term defining one's sexual orientation, generally describing a person's romantic and/or sexual attraction toward someone of the same sex. This term most often refers to gay men, but also can be used inclusively to include lesbian women.

Gender normative: Conforming with social standards that are perceived as acceptable expressions of masculinity and femininity.

Heterosexual: A term defining one's sexual orientation based on the romantic or sexual attraction or behavior between members of the opposite sex (i.e., male-female).

Homosexual: A term defining one's sexual orientation based on the romantic or sexual attraction or behavior between members of the same sex (i.e., male-male, female-female).

Lesbian: A term defining one's sexual orientation, generally describing a female's romantic and/or sexual attraction toward someone of the same sex (i.e., female-female).

LGBT: An acronym that stands for "lesbian, gay, bisexual, and transgender." May also be used in different combinations with additional letters to represent a broader spectrum of identities.

Opposite-sex: A modifier describing a couple as a male-female pairing. See also *heterosexual*.

Same-sex: A modifier describing a couple as a male-male or female-female pairing. See also *homosexual, gay, lesbian*.

Straight: A modifier describing a couple as a male-female pairing. See also *heterosexual*.

Transgender: Identifying with or expressing a gender different from the one that corresponds to the person's sex at birth. May also be used to describe a broader spectrum of non-conforming gender identities and expressions.

Contributors

Andrea Flanagan Photography
Denver, Colorado
www.andreaflanagan.com

p. 4

Authentic Eye Photography
Rumney, New Hampshire
www.authenticeye.com

pp. 23, 41, 61, 74, 83 & back cover

Arguedas Photography
Brighton, Massachusetts
www.arguedasphotography.com

pp. 22 & 29

Brian Pepper & Associates
Orlando, Florida
www.OrlandoWeddingPix.com

p. 54

Arielle Doneson Photography
Wooster, Ohio
www.AriellePhoto.com

pp. 12, 15, 41 & 75

Cean One Photography
Jeremy Fraser
Los Angeles, California
www.ceanone.com

pp. 19, 39, 45 & 57

Ars Magna Studio
Boston, Massachusetts
www.arsmagnastudio.com

pp. 21 & 63

CHARD Photographer
Ladera Ranch, California
www.chardphoto.com

p. 23

Chris Hensel Wedding Photography
Media, Pennsylvania
www.wpjphoto.com

p. 42

Holman Photography
Pacifica, California
www.holmanphotography.com

p. 53

Chris Leary Photography
New York, New York
www.chrisleary.com

p. 16 & back cover

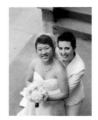

Hudson River Photographer
Rhinebeck, New York
www.hudsonriverphotographer.com

pp. 7, 41 & 74

Dawn E. Roscoe Photography
Chicago, Illinois
www.dawnephoto.com

p. 47

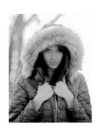

It's Bliss Photography
Schererville, Indiana
www.itsblissphotography.com

pp. 67, 73 & front cover

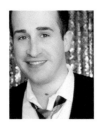

Denver Smith Photography
Chicago, Illinois
www.denversmith.com

pp. 41 & 77

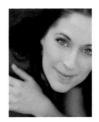

Jen Lynne Photography
Stamford, Connecticut
www.jenlynnephotography.com

pp. 42, 49 & 75

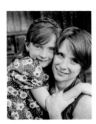

emily g photography
Portland, Oregon
www.emilygphotography.com

pp. 12 & 59

Jimmy Ho Photography
Gainesville, Florida
www.jimmyhophotography.com

p. 51

Julian Kanz Photography
Diano Castello, Italy
www.juliankanz.com

pp. 57 & 69

Leslie Barbaro Photography
North Bergen, New Jersey
www.lesliebarbarophoto.com

pp. 11 & 43

Kat Forder Photography & Productions
Bethesda, Maryland
www.katforder.com

p. 56 & back cover

Lyncca Harvey Photography
Fort Worth, Texas
www.lyncca.com

p. 33

Katie Jane Photography
New York, New York
www.katiejanephoto.com

p. 22

Maggie Rife Photography
Chicago, Illinois
www.maggierife.com

p. 56

Kristin Chalmers Photography
Arlington, Massachusetts
www.kristinchalmersphoto.com

p. 8

Maggie Winters Photography
Arlington, Virginia
www.maggiewinters.com

pp. 27, 31, 65 & 74

Kristina Hill Photography
New York, New York
www.kristinahill.com

pp. 35 & 43

Meredith Hanafi Photography
Washington, D.C.
www.meredith-hanafi.com

p. 22

OffBEET Productions
Jimmy Brosius
Long Branch, New Jersey
www.offBEETproductions.com

p. 9

Sidney Morgan Photography
Hemet, California
www.sidneymorgan.com

p. 37

Purple Apple Studios
London, England
www.purpleapplestudios.co.uk

p. 6

Tammy Watson Photography
British Columbia, Canada
www.tammywatsonphotography.com

p. 25

Retrospect Images
Oakland, California
www.retrospectimages.com

p. 21

Torie McMillian
Chicago, Illinois
www.toriemcmillanphotography.com

p. 71

Sarah Tew Photography
Long Island City, New York
www.sarahtewphotography.com

p. 21 & 75

Unusually Fine
New York, New York
www.unusuallyfine.com

p. 21 & back cover

Sean Gallery
New York, New York
www.seangallery.com

p. 23

Whitmeyer Photography
Lauren Carroll, Tommy Penick
Asheville, North Carolina
www.whitmeyerphotography.com

p. 8

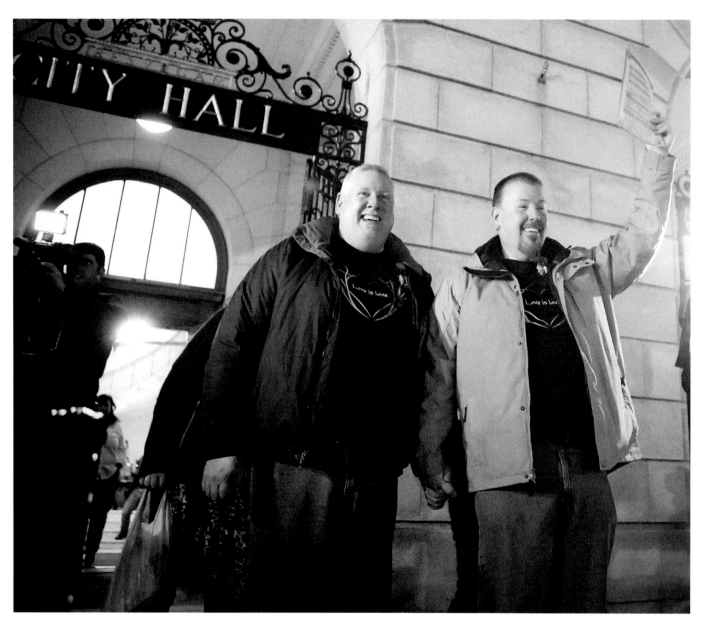

About the Authors

RALPH ALSWANG

WEDDING INNOVATOR KATHRYN HAMM is the president of GayWeddings.com, the leading online boutique and resource dedicated to serving same-sex couples. Since its founding in 1999, GayWeddings.com has supported thousands of same-sex couples and LGBT-friendly vendors.

Kathryn writes, speaks, and consults about why same sex weddings are meaningful and why marriage matters. In addition to writing for GayWeddings.com, she has written articles for *The Huffington Post* and WeddingAces. She is a valued resource for media outlets such *The New York Times*, the *Washington Post*, CNN.com and CNBC.com. She also gives presentations to groups from professional organizations who want to learn more about same-sex weddings.

Kathryn holds an M.S.W. from the Catholic University of America and an A.B. in Psychology from Princeton University. Prior to becoming the president of GayWeddings.com, Kathryn spent ten years as an educator and school administrator in the Washington, D.C. area. Though she and her partner of twenty years exchanged vows in a memorable ceremony on the Eastern Shore of Maryland in 1999, they are not yet legally married.

AUTHENTIC EYE PHOTOGRAPHY

WEDDING PHOTOGRAPHER THEA DODDS, an award-winning photojournalist with more than fifteen years of experience, founded Authentic Eye in 2004. Thea also co-founded the internationally recognized non-profit Greener Photography in 2008.

Thea's work has been featured in various publications, including *Newsweek*, *The Lakes Region of New Hampshire*, *Kearsarge Magazine*, *Vermont Vows*, and *NH Magazine's Bride*. She has received recognition in international photographic competitions and has been featured in prominent online wedding publications, such as GayWeddings.com.

Authentic Eye provides exceptional personal, corporate, and artistic photography services and has been photographing same-sex weddings in New England since 2005.

Thea is also the proud parent of two young children, Kyra and Aubrie. She lives with her family in the small town of Rumney, New Hampshire, on a ten-acre farm, enjoying the stewardship of chickens, honeybees, and fresh maple syrup.

CPSIA information can be obtained
at www.ICGtesting.com
Printed in the USA
LVIC01n1943200813
348823LV00002B